NATIVE AMERICAN
FETISH CARVINGS
OF THE SOUTHWEST

KAY WHITTLE

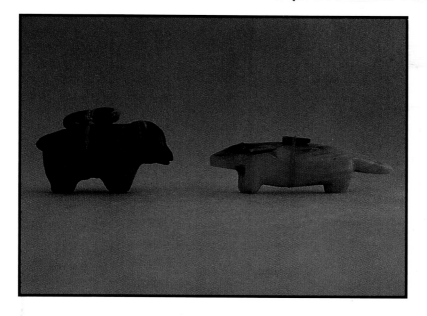

4880 Lower Valley Road, Atglen, PA 19310 USA

Dedication

For Jay and Kevin,
who endured this project with patience and humor,
and in memory of Sweeney Todd and Skeezix,
faithful friends and guardian spirits, who couldn't.

Copyright © 1998 by Kay Whittle
Library of Congress Catalog Card Number: 97-81266

Designed by Laurie A. Smucker

Typeset in Times New Roman/Lithograph
ISBN: 0-7643-0429-1
Printed in China
1 2 3 4

Published by Schiffer Publishing Ltd.
4880 Lower Valley Road
Atglen, PA 19310
Phone: (610) 593-1777; Fax: (610) 593-2002
E-mail: schifferbk@aol.com
Please write for a free catalog.
This book may be purchased from the publisher.
Please include $3.95 for shipping.
Try your bookstore first.

We are interested in hearing from authors
with book ideas on related subjects.

TABLE OF CONTENTS

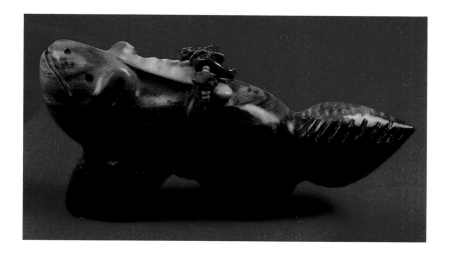

ACKNOWLEDGMENTS

Without various kinds of good-natured help, this book would never have come together. I am grateful to family and friends for both practical and moral support over the past year, especially Jay, Kevin, and Mabel Graepel. Their interest and encouragement made it easy for me to undertake this project. I am also grateful to Chris Williams for organizational aid, Jayne Graepel for locating an invaluable local resource, Chris Staley and Ken Kreklau for photographic tips, Liz Ruff and Bobby Ruff for creative artwork, and Ric Whittle for computer support. Special thanks go to Challis Thiessen for her enthusiastic advice and fine camera work and to Cara Wilkinson and Chris Pavlov of Turning Point Gallery for "kindness to strangers" and for bringing interesting images to my attention.

I am indebted to Schiffer Publishing, Ltd., especially Peter Schiffer and Douglas Congdon-Martin. First, they gave me a reason for doing what I wanted to do anyway. Along with my editor Tina Skinner, they offered editorial advice on how to proceed. Thank you to Peter and Nancy Schiffer for lending their photographic expertise to this project, and to the Schiffer production team for making it all look good.

Finally, I appreciate the combined effort, goodwill, and cooperation of the following contributors, who shared their wonderful collections:

Generous private collectors who have chosen to remain anonymous.

Ian M. Schwartz, Adobe East Gallery, Summit, New Jersey.

Al and Heather Anthony, Adobe Gallery, Albuquerque, New Mexico.

Andrews Pueblo Pottery and Art Gallery, Albuquerque, New Mexico.

Ailene and Erik Bromberg

Ray Dewey and Peter Waidler, Dewey Galleries, Ltd., Santa Fe, New Mexico.

The Estate of Katherine L. Fitch

Dolores Fitch-Basehore and Richard L. Basehore, Fitch's Trading Post, Harrisburg, Pennsylvania.

Laverne Zell and Dr. Al Rogers, Eicher Indian Museum Shop, Ephrata, Pennsylvania.

Gary's Gem Garden, Cherry Hill, New Jersey.

Bill Malone, Hubbell Trading Post, Ganado, Arizona

Kiva Indian Trading Post, Santa Fe, New Mexico.

Marjorie Levitan

Guy Berger and Steve DePriest, Palms Trading Company, Albuquerque, New Mexico.

Southwestern Indian Art, Inc., Gallup, New Mexico.

Challis and Arch Thiessen, Sunshine Studio, Santa Fe, New Mexico.

Beth Fluke and Connie Medaugh. Tumbleweed Trading, Manayunk, Pennsylvania.

Cara Wilkinson and Chris Pavlov, Turning Point Gallery, Media, Pennsylvania.

Cathren Harris and Mary Cathren Harris, The Turquoise Lady, Albuquerque, New Mexico.

Carol S. Stocker, The Turquoise Shoppe, Lititz, Pennsylvania.

INTRODUCTION

There's no quick and easy way to explain an interest in fetish-collecting to non-enthusiasts. The usual scenario goes something like this:

"Excuse me? You say you're interested in fetishes?!" [eyebrows raised]

"Well, yes, Native American fetishes," you clarify.

"Well ... I'll be ... That's a hobby?" [raised eyebrows twitch]

"Well, yes. More than that. It's a passion!" you reply with enthusiasm.

"Hmmm." [lengthy, expectant silence]

At this point you're better off pushing ahead than trying to guess what turn the conversation might take next.

"Native American fetish carvings," you amend, catching on. "You know, those wonderful animal figures hand-carved from stone, bone, antler, or shell by skilled Native American crafts persons in the Southwest."

"Oh yes, of course!" [shoulders slump, eyebrows still]

Now you can move on to a discussion of how and why you like them confident that nothing you say can possibly generate the interest of your opening salvo.

When I purchased my first Native American fetish carving ten years ago, a palm-sized standing bear of bone and incised turquoise, it spoke to my abiding interests in rock and mineral collecting and animal lore, as well as an enthusiastic appreciation of ethnic folklore and art. I'd always enjoyed the classical concept of the sculptor's role, that of freeing the image from the stone which imprisons it. Some carvers in the Zuñi tradition describe their work in much the same way.

Once introduced to this art form, I began to notice them in lots of unlikely places—inspirational stores, nature stores, gem shops, exotic gift shops—as well as their traditional outlet in stores specializing in Native American crafts. The more I looked, the more carvings I found; the more I found, the more I wanted to know about them, their makers, materials, symbols, the cultures which produced them and the folks who buy them. And thus this book was born.

While I've not exhausted the subject, I have followed my interests along a path traveled by other writers with different interests. Several fine books were helpful, from the classic studies of Frank Hamilton Cushing (*Zuni Fetishes,* 1883, reprinted 1988) and Ruth Kirk (*Zuni Fetishism,* 1943; reprinted 1988) to wonderful contemporary books, especially Marian Rodee's and James Ostler's *Fetish Carvers of Zuni* (1990), Hal Zina Bennett's *Zuni Fetishes* (1993), Harold Finkelstein's *Zuñi Fetish Carvings* (1994), and Kent McManis's *Guide to Zuni Fetish Carvings* (1995). But I wanted to explore in greater depth the meanings and symbolism associated with fetish carvings by the artists and cultures which produced them. Researcher and storyteller at heart, I turned to ethnological studies, stories and legends, and personal interviews for some of this information. The result of this labor for me has been increased pleasure in the carvings and sincere admiration and respect for the artists and cultures which produced them.

Along with the photographic images in this book, representative prices are included as guidelines to help you find your way around the market. However, these values are useful only as estimates. In many cases, the ranges noted are averages. For example, in the case of one carving by Dan Quam, a $150 difference in price was assessed and defended staunchly by two galleries, one specializing in Native American artwork, the other in spiritual wellness. Despite efforts to standardize them, prices remain fairly stable but eccentric, depending on the shops in which they are sold and the retailers' knowledge of the products.

A Fetish by Any Other Name

The term "fetish" is derived from the Portuguese *feitço*, suggesting "a charm or sorcery." It survives in North American dialects as a relic of the Spanish conquest. Like charms, generic *fetiços* exist outside of any particular religion, pertaining instead to material objects which embody mysterious or incomprehensible powers observable in nature. In this sense, practically any object can be classified as a fetish. (This fact accounts for the raised eyebrows in my opening scenario.) The rabbit's foot, four-leafed clover, and evil-eye bead from other cultural traditions are *fetishized* objects to the extent that they are viewed with awe or reverence or are believed to possess the power to change the course of events for good or ill.

Aside from the conventional titillation associated with the word *fetish*, other problems shadow its usage. For several reasons, experts agree that the word "fetish" does not accurately represent the contemporary art carvings which have become a hot item on the ethnic art market. Within the traditions of the cultures which make and use them, fetishes are sacred objects, believed to represent powerful animal spirits or natural forces. Because the Zuñi have inextricably integrated these sacred objects into both public and personal ritual, some experts recognize only Zuñi fetishes as "real fetishes." These individuals often grant the same "exclusivity" to the Hopi for their kachinas and the Navajo for their weavings.

However, the proximity of these cultures as well as widespread trading, despite the diversity in languages, has facilitated borrowing and improvisation among the tribes. As the demand for these items increased over the past decade, more and more artists both inside and outside the Zuñi cultural tradition began to make and market them. Some, wonderfully original and skillful interpretations of the tradition, deserve respect. Poorly executed copies, however, do not. It is no wonder some Zuñi artists and sympathetic dealers have adopted proprietary attitudes toward the genre. Borrowing without permission is rightfully resented.

Yet, the modern world has changed the scope of the enterprise in a way that can probably not be undone. Increased communication and travel among special tribal events, enrollment of talented Native American artists in art schools and colleges across the country, and the demands of the commercial marketplace have loosened the proprietary hold some tribes and some families have placed on the industry.[1] I propose to recognize the ascendancy of Zuñi carvers, but at the same time to honor excellent or interesting work by Native American carvers from other tribes.

Still other experts use the *fetish* to refer to sacred objects made for religious use and the term *carvings* to refer to the figures produced for sale. Some "real" fetishes (that is, fetishes actually used ceremonially within the tribe) may be carved, decorated, or prepared in secret ways to differentiate them from the carvings offered for sale. Milford Nahohai of the Zuñi Arts & Crafts tribal enterprise stresses the fact that even carvings meant as sacred objects do not become fetishes "in the true Zuñi sense" until "blessed by the tribe's medicine society at the annual Winter Solstice gathering."[2] Mark Bahti recalls seeing a store-bought plastic horse, much like a child's toy, decorated with feather and stone bundles and thus empowered as a fetish by a Zuñi religious leader.[3]

If indeed belief in its efficacy distinguishes fetishes from carvings, perhaps we do use the word too indiscriminately. Yet in the course of this study, I have spoken with many collectors outside of the Native American tradition who profess belief in the efficacy of fetishes. In a sense, then, many carvings bought and used by outside cultures are empowered as fetishes in the traditional sense, and so deserve the name.

However, the beliefs associated with fetishes by outsiders often do not coincide with those of the Native American cultures who hold them sacred. That's not surprising, since

their meaning varies even among the Indian cultures which honor them. Fetish images carry different symbolic values in different pueblos. For example, the bear, associated predominantly with curing or medicine in traditional Zuñi religious practice, controls significant war powers among the Hopi tribe.

Fetish Appeal: Why We Buy Them...

Fetish carvings are collected outside of Native American culture for many reasons. The reasons we buy them are as plentiful as the styles, forms, and materials of which they are composed. Some collectors desire them for purely aesthetic reasons, as affordable, hand-crafted, individually-wrought sculptures. Others prize them for the mostly natural materials of which they are composed (stone, wood, shell, bone, feathers, sinew), a refreshing change from plastic and *faux*-everything else. Still others, often animal-lovers, believe they reveal and reinforce the integral roles animals perform in a human-dominated world. The fastest-growing contemporary market for fetish carvings exists among collectors who seek to tap the spiritual energy of traditional Native American life-ways as a way of understanding, explaining, or even escaping the demands of a fast-paced, impersonal modern world.

Increasing numbers of outsiders purchase and carry them to draw good fortune or to ward off ill luck. Dealers report that buyers are increasingly interested in learning the spiritual associations connected to the image which attracts them, taking for granted that the images possess a meaning or power beyond the physical form itself. Knowing the meaning enhances the enjoyment of the piece even among buyers who don't believe that the carvings can channel power.

This curious thirst for meaning contributes to what anthropologist Barbara Tedlock (who visited Zuñi and studied its people over a period of twenty years) describes as a "distanced aesthetic enchantment" with both the artifact and the culture from which it derives. Indeed, as we try to make or to read meaning from these images, we join ethnographers and anthropologists in the very human enterprise of "gathering, inscribing, and interpreting what Others say and do in order to make sense of our own sayings and doings."[4]

From Early Trading to Modern Markets

Extensive trading occurred among the native peoples as early as AD 600-900. By AD 1250 Zuñi villages had become centers of intertribal trade. Corn, salt, turquoise, cotton cloth, jewelry, baskets, pottery, moccasins, and blue paint were traded to peoples of Mexico, California, and the Great Plains for pottery, copper, parrot feathers, seashells, coral, and buffalo hides. Zuñi carvings were among the trade items that made their way throughout the southwestern and western trade routes. Most served religious uses within the tribes who bartered for them.

By the mid-sixteenth century the Spanish had arrived in search of the reputed treasures of the Seven Cities of Cibola (Francisco Vasquez de Coronado) and spiritual conquest (Friar Marcos de Niza). The Zuñi did not make good subjects, as the Spanish discovered. Tribute was rarely paid without a battle, dangerous and costly to both sides. Missionaries treated the natives brutally, persecuting as witches those who continued to practice their religion. During this time of religious repression, the large, altar-sized fetishes are said to have given way to a smaller, palm-sided form which could be easily hidden. Both are used ceremonially today; in fact, the small ones are said to receive power from proximity to larger ones.

In August 1680 the Zuñi joined other Pueblo tribes in a successful revolt which gave them twelve years of respite from Spanish control. However, by 1692 the Spanish returned and remained until 1821 when Mexico loosely held the territory, surrendering it to the United States at the close of the Mexican American War in 1848.

By the time westward expansion of the United States brought the railroad to Gallup in 1881, the cultural landscape had changed forever. The American Bureau of Ethnology sent repeated expeditions to the area in 1879, 1881, and 1884; the Hemenway Southwestern Archeological Expedition converged on the scene in 1888-89. Its mission was to analyze and describe the characteristics of the cultures found there. Most of what we know of the history of Zuñi comes from the annals of these ethnologists: James Stevenson, Matilda Coxe Stevenson, Frank Hamilton Cushing, Elsie Clews Parsons, Ruth Bunzel, Ruth Benedict, Frederick W. Hodge, and Alfred Kroeber. Today's central village lies along the banks of the Zuñi River, a tributary of the Little Colorado. The reservation covers approximately 400,000 acres, home to roughly 10,000 modern-day Zuñi.

Outsiders did bring a new market for Native American products though. Purportedly *found* fetishes had been sold to collectors all along. By the 1880s, however, the Zuñi were carving them for sale in a commercial market, mostly that of anthropologists and collectors lusting after pieces of the Indian culture. Therefore, age need not guarantee authenticity. Collectors must be aware that even fetish carvings appraised as nineteenth century artifacts may never have been used as sacred ceremonial objects (Kenagy, 18).

Fetish carving did not become an industry until Indian jewelry became popular with outsiders in the mid-1900s. During the late nineteenth century, Zuñi artisans learned silver smithing from their Navajo neighbors to the north. Since the demand for carvings alone was small, Zuñi artists incorporated their exquisite stone work into the silver jewelry they wrought.

The efforts of traders like C. G. Wallace and John Kennedy are largely responsible for establishing a market for Native American products, including fetishes. They encouraged artists to try new materials and tools, promoting sales and helping to develop a corps of buyers. Channeling the supply of raw materials into the pueblo, they also marketed the finished products. When so-called fetish necklaces became popular during the 1960s and '70s, traders generally bought the individually carved pieces and strung them with hand-crafted beads or *heishi*, a specialty of the Santo Domingo Pueblo.

The 1980s witnessed a boom in the popularity of Native American arts and crafts. The groundwork for this boom was laid in the '70s when the Whitney Museum of American Art staged an exhibition and published an accompanying book (*Two Hundred Years of American Indian Art* by Norman Feder) which introduced these ethnic crafts into the New York market. Power tools and modernized techniques, exotic carving materials, innovative carving styles, and a growing interest in affordable, authentic items solidified the demand for these products (Rodee and Ostler, 22-31).

Assigning value to fetish carvings has become a complicated process. Consummate crafts persons, Zuñi artists rarely judge their work or the work of others in terms of beauty or artistic design. Instead, they assess value based on the difficulty or delicacy of the work: the difficulty of cutting the stone, the amount of wasted material due to fracture, the time it takes to shape, carve, polish and adorn. As a result the price of fetishes as ethnic craft products has remained fairly stable over the past decade, fluctuating by less that twenty percent. However, pieces accepted into the market as art may appreciate five-hundred percent or more (Rodee and Ostler, 32-41). Seventy-five percent of fetishes were priced between $3-$10 in 1983; by the early nineties half cost between $12-$200. These prices have risen, especially on unique styles, unique stones, or popular animals (like bears). Moderate-quality pieces will cost $40-$80, while top quality carvings are valued in the hundreds.[5] The work of well-known artists (like Leekya Deyuse) or of rare antique quality may climb into the thousands.

Most carvings are still brought to the local traders for sale and distribution. Some dealers or gallery owners make regular purchasing trips to the area. The Zuñi Pueblo government established the Pueblo of Zuni Arts and Crafts enterprise to market these products from Zuni, while huge exhibitions such as the bi-annual shows of the Indian Arts and Crafts Association (IACA) and Santa Fe's Indian Market (juried by Southwest American Indian Art or SWAIA) bring together dealers, collectors, and artists in one place. Mail order catalogs and internet web pages ensure a broad, worldwide market.

Of course the popularity of these figures and the money to be made from them has encouraged the production of fakes. (Fake pictured on Page 12) Unscrupulous dealers sell as authentic products imported figures (some hand-carved but most mass produced) from Mexico, the Philippines, Hong Kong, Asia, etc. Other items may be sold by local artists who are not Native Americans, while still others that are sold by Native Americans were not made by them.

The Indian Arts and Crafts Association, established in 1974, tries to protect and promote authentic Native American culture and art. Member artists pledge to maintain specified standards in their work, and retail members display the IACA logo in their stores as a pledge that their merchandise is genuine. The only hope for buyers who are still learning their way around is to find a trustworthy dealer and ask questions. IACA recommends that you find out who carved the piece, to what pueblo or tribe the carver belongs, what the image represents, and of what material it is carved. It's a good idea to keep a record of this information to establish the provenance of the piece of art you've collected.

Two problems combine, however, to thwart this system. First, judging by the membership directory published by the IACA, relatively few Native American carvers belong to the organization. For example, few of the many carvers mentioned in this book are listed in the latest (1996) buyer's guide. Second, on the dealers' end, careful record-keeping is essential to identify and authenticate the artwork. In recent travels related to this book, I've been in many, many shops and galleries. Some owners are meticulous about their record-keeping and highly knowledgeable about the items they sell. Others, however well-meaning they may be, allow their enthusiasm for variety to outweigh the need for documentation. They offer for sale a mixed bag of merchandise (some wonderful, some not-so-wonderful), carelessly labeled and poorly displayed. In one gallery I visited (not one used in this book, needless to say), the store manager noticed that the fetish jar I was examining had a hole in the side. He apologized to me for the "broken" fetish jar, offering to find me an undamaged one. He was apologizing for the feeding hole, an essential element of the jar!

Notes

[1]Susan Kenagy, "Made in the Zuni Style: Zuni Pueblo and the Arts of the Southwest." *Masterkey* 61, no. 4(1985):18.

[2]L. A. Winokur, "Pushing Their Luck: Zuñi Indians Peddle 'Magical' Charms," *Wall Street Journal* (April 28, 1993):A1,A6.

[3]*Southwestern Indian Arts & Crafts.* Revised Edition. (Las Vegas, Nevada: KC Publications, Inc., 1983): 16. The late Tom Bahti, well-known dealer, collector, anthropologist, and expert in Southwestern Indian arts and crafts, ceremonials, and tribal culture, is perhaps best known outside the Southwest for having in 1966 introduced the work of late nineteenth-century ethnographer Frank Hamilton Cushing to popular audiences.

[4]*The Beautiful and the Dangerous* (New York: Viking Press, 1992): xi.

[5]Stephen Parks, "The Magic Breath of Prey," *Indian Trader*, 21, no. 7 (July 1990): 5.

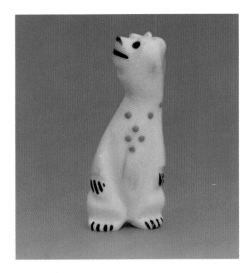

Bone bear, 2.25", wears turquoise inlay necklace and shows lots of "attitude." Made by Barney Calavasa. $65-75. (*Courtesy of private collection.*)

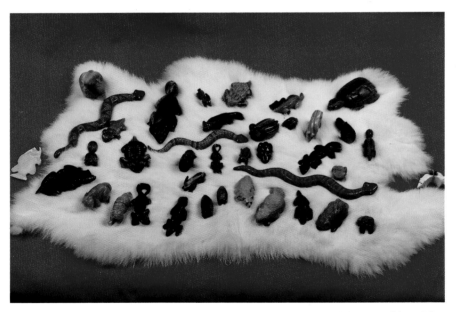

An assortment of fetishes in all shapes, sizes, styles, colors, and materials. Just a hint of the variety available. (*Courtesy of Andrews Pueblo Pottery and Art Gallery, Albuquerque, New Mexico.*)

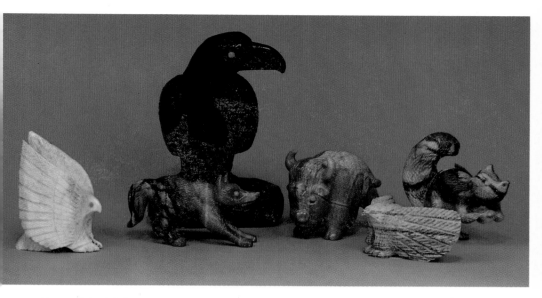

Group of Zuñi fetishes. Left to right: antler eagle, 1.5", by Herbert Hustito, $150-175; picasso marble fox, 2", by Dan Quam, $180-200; jet raven, 4", by B.C., $150-170; picasso marble buffalo, 1.5", by Dan Quam, $400-450; serpentine eagle, 1.5", by Elfina Hustito, $75-90; picasso marble squirrel, 2", by Arvella Cheama, $150-170. (*Courtesy of Turning Point Gallery, Media, Pennsylvania.*)

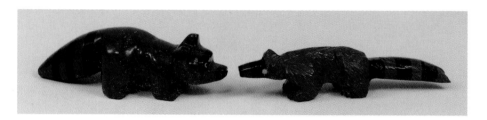

Two interpretations of the raccoon figure in pipestone and jet. Left: 3", carved by Navajo artist Julia Norton, $35-45; right: 3", carved by Zuñi artist Barney Calavasa $35-45. (*Courtesy of The Turquoise Shoppe, Lititz, Pennsylvania.*)

One of the most popular and recognizable contemporary bear styles, 2.25". Carved of beautifully patterned picasso marble and brought to a high polish by Zuñi artist Stewart Quandelacy. $150-175. (*Courtesy of Ian M. Schwartz, Adobe East Gallery, New Jersey.*)

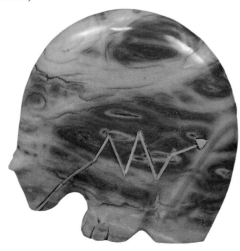

11

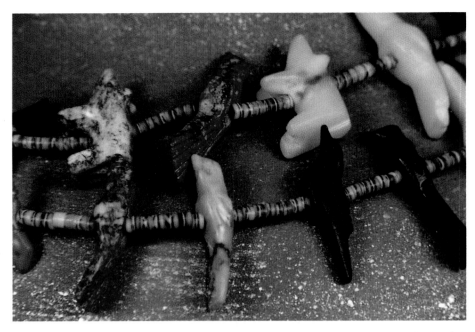

Pierced fetishes strung with heishi. 1960s. Artist unknown. $900. (*Courtesy of Fitch's Trading Post, Harrisburg, Pennsylvania.*)

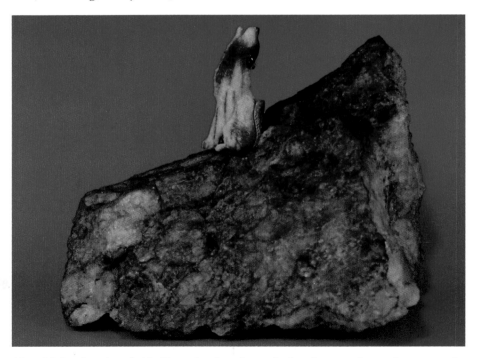

Not a Native American fetish. Example of carvings mistaken for, sometimes misrepresented as, fetishes. This small howling wolf figure, 1", was carved in Indonesia of walrus ivory imported from North America. Then it was exported back to the United States and sold as an authentic fetish. $45. (*Courtesy of private collection.*)

Chapter 1

FETISHES IN THE OLD AND NEW AGE

Zuñi Traditions

To understand the purpose of the fetish in Zuñi traditions it is necessary to think of the universe as infused with spirit. Animate and inanimate objects alike contain thinking, aware spirits possessed of various levels of power. And all the spirit-infused pieces of the world relate to one another in very important ways. The Zuñi universe, created by *Awonawilona* or the Great Spirit, consists of nine layers: four layers of sky, four layers of underworld, and the earth—a middle place surrounded by oceans.

This complex mythological and religious system aims at keeping balance in this highly structured world. To ensure harmony among all related parts of the natural world, stories and laws emphasize the absolute necessity of cooperation. Working together, behaving properly, and showing respect for ancestors and gods keeps the world in good order, with plentiful food and adequate rain.

Two central concepts of this world view turn upon faith in the relatedness of all things and the power of mystery. Since a touch upon a single strand reverberates throughout the web, understanding relation is important. Relatedness can be discerned through resemblance. For example, snakes with their zigzag movements and razor-sharp fangs are related to and strengthened by their resemblance to the erratic power of lightning. Arrow points, with their sharp edges and erratic lines, recall both the powerful forces of the lightning and the sharp fangs of the snake. All three share power through their relatedness and resemblances.

By the same token, objects or forces which mystify the human mind assume positions of great power. Unpredictable and largely uncontrollable, animals are thought to possess special power. In the ensuing hierarchy, animals are related to gods and the elemental forces of nature by their inscrutability. At the same time, animals are related to humans through mortality, which they share. They possess skills (flight, fleetness, ferocity, etc.) which humans lack. Humans use fetishes to harness the powers of animals for use in their own lives.

The first fetishes, called *Ahlashiwe* or *stone ancients*, found in archaeological digs dating to the seventh century, were mostly natural concretions, vaguely resembling familiar human and animal forms. The earliest and most powerful fetishes, they are believed to be the petrified bodies of animals who inhabited the earth prior to the emergence of humans from the dark caverns of the underworlds. The point of Emergence varies among the Pueblo tribes. The Hopi emerged into the surface world through a blow hole at the bottom of the Grand Canyon, while the Navajo appeared at the base of Black Mountain. The Zuñi swam from the series of "womb-worlds" below the salt lake near the Colorado River.

At the surface, fierce animals threatened the emerging humans. Lightning arrows shot from the rainbow weapon of the Twin Sons of the Sun-Father turned many beasts to stone. Their hearts, however, remained alive within the stone for the purpose of helping humankind.

These first fetishes are characterized by large bodies and heads on small, knobby legs. Thick forms were easier to shape with rough tools and less likely to break. Also, the more abstract the form, the more mysterious; the more mysterious, the more powerful. (See Pages 16-17) However, as time passed, enhanced human-like (anthropomorphic) and animal-like (zoomorphic) features made them more identifiable. In older fetishes anatomical details like the anal hole beneath the tail acknowledged the living force or spirit within the stone.

Plentiful Zuni stone was the primary material used in these early fetishes, although sometimes clay figures were produced. They were then painted the appropriate color for the figure or direction represented. A leather thong, sinew from ceremonially killed deer, encircled the middle. Feathers from select species of birds added special powers, and turquoise and shell beads expressed appreciation for services rendered. Size may have been a sign of value, i.e., larger images were considered more important than smaller ones.

The animal images have a special relation to Finished Beings (the dead). Humans experience a special relation with the animals in whose form they return to the world. Separated from their daylight existence by four deaths, humans return to the place of emergence whence they came and descend through four underworlds. (Note that *four* is a sacred number in this cosmology.) They may return to the world as animals four times, depending upon the knowledge gained in each life. For example, members of the Society of the Complete Path might return as mountain lions, bears, badgers, wolves, eagles, moles, rattlesnakes, or ants; witches might return as coyotes, lizards, bull snakes, or owls. Members of the Kachina Society return as deer.

Traditional Uses of Fetishes

Properly used, fetishes are believed to offer powerful aid in hunting, diagnosing and curing disease, mediating between gods and emissaries, initiation, war, betting and gaming, farming, weather control, fire-making, propagation and fertility, witchcraft, defense against witchcraft, and punishment.

Fetishes protect and assist individuals or groups. They may be stored communally, as in tribal or kiva fetishes, or individually, as in medicine bags or (more recently) stringing fetishes, although the latter are mostly decorative. Carved of antler and decorated with hair, feathers, shell, turquoise, coral, or arrow points, kiva fetishes (also known as Clan or Society fetishes) are generally kept in a guarded location—sometimes in special clay vessels—in the kiva, an underground ceremonial house which serves as a sacred chamber for the rituals or ceremonies of its members.[1]

Personal fetishes can take practically any form: bone, feather, painted stick, arrowhead, fossil or concretion, hair, animal and reptile skins, carved stone. The shaman's medicine bag might include fetishes of roots, bark, berries, powdered potions or feathers. Fetishes may be received as gifts from a medicine priest, inherited by families, or taken as trophies from defeated enemies or slain animals. Owners may choose appropriate figures to represent their dreams or imagination, hoping for a psychic connection with a larger power. An individual may own one or many such fetishes, keeping them in pockets or small leather pouches strung on rawhide about the neck or dangling from their waist. A Navajo medicine bag, sometimes lizard- or turtle-shaped, might also contain the umbilical cord of the owner, carried for good luck throughout life.

Fetishes which bring the most consistent results get the most attention. To sustain the power of the fetish, the owner must feed it (cornmeal, pollen, wood ash), protect it, and make offerings of turquoise, coral, shell or feathers. The combination of these

substances recalls all the essentials of life. Cornmeal, a staple of the human diet, is shared with the fetish to cement the relationship between humans and the spirits who control the world. Shells recall the essential value of water, while turquoise represents the awe of finding blue sky embedded in the earth. Pollen fertilizes the corn plant, completing the cycle. Regardless of the outcome of an event, the fetish is never blamed for failure to perform. If it does not work, that failure is charged against its owner. Fetishes never fail owners who are honorable and true.

Tribal use of fetishes is as prevalent today as in the past. Among the Zuñi they are still used for hunting, still worn as protection and for healing. They may be placed in the walls of homes as protection or buried in fields to encourage crops. They are still taken to winter solstice ceremonies to be blessed. During the 1940s, priests revived war ceremonies to protect Zuñi men inducted into the US armed forces. Soldiers returning from war underwent ritual purifications before they were allowed to return to the villages. Much of this ritual and pageantry, however, has been lost over the years (Kirk, 50).

Fetishes and New Age Animal Medicine

New Age animal medicine accounts for much of the contemporary interest in collecting and using Native American fetish carvings. Consider the 1993 article in that bastion of modern American corporate culture, *The Wall Street Journal*. A growing number of mainstream business executives and professionals buy and use Native American fetish carvings for career success. A trial attorney claims that her bear fetish helps her "balance" aggression and patience in the courtroom. A professional photographer uses the buffalo fetish as a symbol of abundance, hoping to land many projects. Two computer-software executives carry along an eagle fetish to big trade shows to help them "get a better overview of what's going on" (Winokur, A1).

Although some tribes have objected to outsiders' use of these items as spiritual guides, Joseph Dishta of the Zuñi tribal council claims that his people rarely resent such use. Noted carver Lena Leki Boone, who believes in the efficacy of fetishes, knows that some of her customers buy fetishes for their reputed power to bring luck and health. "But in my work I don't guarantee it," she reminds (Winokur, A6).

Author and practitioner of psychic medicine, Hal Zina Bennett explains how contemporary non-Native American society uses animal images for meditation. The object serves as a "symbol, a reminder, a way to help its owner hold in his or her mind an important and usually complex concept ... the object doesn't possess power so much as it evokes it."[2]

The modern practice of animal-spirit medicine actually evolved through observation of nature, just like the spirit medicine of the earliest peoples but often with strikingly different manifestations. Take the butterfly image, for example. Because a butterfly has a symmetrical beauty, fanciful interpretations say that its image "means" beauty or grace or balance. Among the Zuñi, however, the butterfly is more likely to be associated with rain or corn or summer than with beauty. And in stories from the San Juan Pueblo, the butterfly brings not beauty but knowledge of weapons and the tactics of war.

Be warned. In an essay on Native American symbolism endorsed and published by the Indian Arts and Crafts Association (IACA), Barton Wright describes the distortion which occurs when one culture tries to read and interpret the signs or symbols of another. Traditional images may symbolize an "idea, quality, or an association, a shared convention that through time has come to mean a specific thing to a particular group of people." Yet removed from the spiritual tradition of that culture, they become simply designs, their meanings lost, altered, or misapplied.

In an interesting example, he discusses the swastika design which appears in Native American weavings. (I've been unnerved to see it in Amish quilts!) A sinister symbol to much of the world, in weaving it represents a natural design created when "the ends of a simple cross design are turned either to the right or left, depending on the direction of the weaving."

Another interesting example of misapplied cultural beliefs documented by Wright describes how the thunderbird image, supposedly symbolizing happiness, came to be associated with Southwestern Indian cultures. Apparently the thunderbird was brought to the Southwest as an industrial die-cut for stamping jewelry. Adaptive as always, Native American crafts persons incorporated it into their work in spite of the fact that the thunderbird holds no place in their system of beliefs. Both the Zuñi Knife-Wing Spirit and the Hopi Vulture Kwatoko do figure in Southwestern mythology, but they appear in distinctly different forms than the ubiquitous thunderbird. The thunderbird does have a representative form among Plains Indians, where it is linked to intense, powerful thunder and lightning storms — not happiness.

Notes

[1] The entrance to the kiva, located on the roof, symbolizes where the first people emerged to inhabit the land's surface. A ladder leads inside where one finds a fire pit, altar, sipapu, and sometimes a banco. When a ceremony is in process, a *nachi* (feathered stick or sticks) is raised on top. Villages will have a kiva to represent each individual clan and, of course, women may not enter them. Exactly how the fetishes are used in the kiva is known only to those initiated into the different kiva societies.

[2] *Zuni Fetishes: Using Native American Objects for Meditation, Reflection, and Insight* (San Francisco: HarperSanFrancisco, 1993): 66-67.

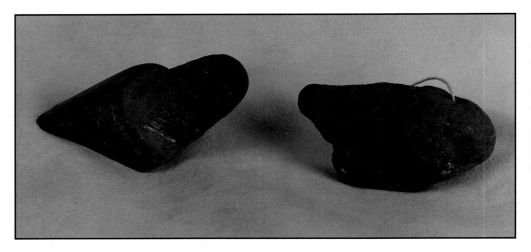

Two antique fetishes, 2", identified as frogs. Texture is rough and the form is abstract. The figure on the right is pierced for hanging. (*Courtesy of The Turquoise Lady, Albuquerque, New Mexico.*)

Stone mountain lion, 5.25". From Mimbres prehistoric period. Etched heartline runs the entire body, throat to rear. $1,500. (*Courtesy of Dewey Galleries, Ltd., Santa Fe, New Mexico.*)

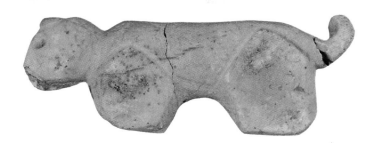

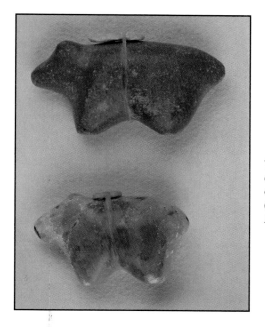

Two figures, probably bears. 1950s. Zuñi carver unknown. Each carries a turquoise offering on its back. $375-400 each. (*Courtesy of Dewey Galleries, Ltd., Santa Fe, New Mexico.*)

Red stone mountain lion, 2.25". Traditional style with tail lying parallel to spine. Cochiti Pueblo, carver unknown. $450-500. (*Courtesy of Dewey Galleries, Ltd., Santa Fe, New Mexico.*)

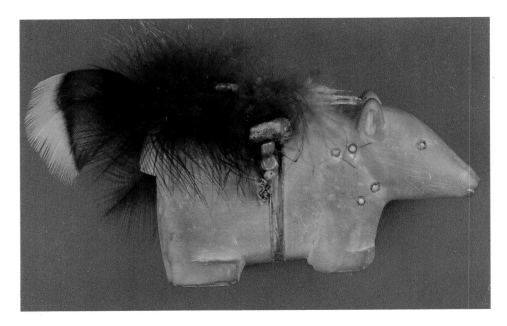

Large bear fetish carved of clay, 1950s. Turquoise inlay may identify bear with the Blue Bear, Guardian of the Western Region. Feathered bundle includes shell point, turquoise, and coral nuggets. Feathered bundles are unusual in Zuñi work. (*Courtesy of Dewey Galleries, Ltd., Santa Fe, New Mexico.*)

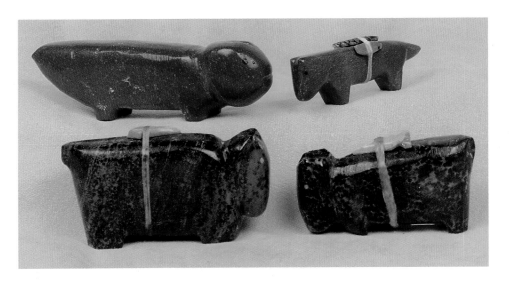

Four fetishes carved in old style. Top left: pipestone wolf or coyote with small turquoise eyes. Top right: pipestone coyote or wildcat with shell and turquoise bundle. Bottom left: serpentine bear (?) with turquoise point bundle and eyes. Bottom right: moss serpentine mountain lion with turquoise bundle and eyes. $25-35 each. (*Courtesy of Adobe Gallery, Albuquerque, New Mexico.*)

Sarah Leekya (Zuñi) fashioned these bear and bird fetishes, each 0.75", from turquoise with a beautiful matrix. Bear has coral inlay eyes; bird has jet ones. Bear: $80-90. Bird: $60-70. (*Courtesy of private collector and Adobe East Gallery, Summit, New Jersey.*)

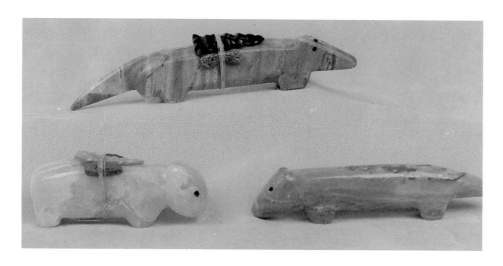

Three Zuñi fetishes by the Sheche family. Top: double wolf figures carved from the same stone by AS. Bundle is jet and coral, eyes are jet. Male has long tail, $40-60. Bottom left: alabaster mountain lion with shell, coral, and turquoise bundle and jet eyes, $40-50. Bottom right: green serpentine wolf with jet eyes, $35-45. (*Courtesy of Adobe Gallery, Albuquerque, New Mexico.*)

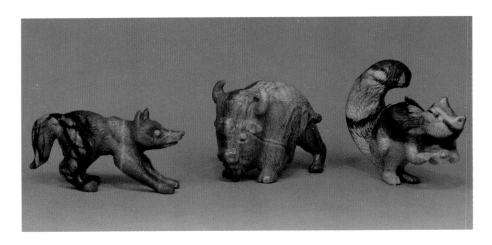

Three Zuñi fetishes of picasso marble, carved in realistic, contemporary style. Left: fox, 2", by Dan Quam, $180-200; Middle: buffalo, 1.5", by Dan Quam, $400-450; Right: squirrel, 2", by Arvella Cheama, $150-170. (*Courtesy of Turning Point Gallery, Media, Pennsylvania.*)

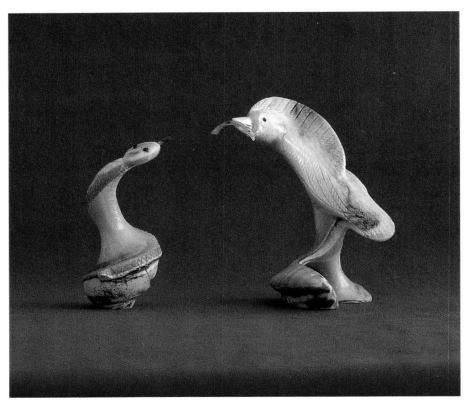

Curves of green snail shell take on the forms of snake and bird in these two carvings by an unknown Zuñi artist. Snake, $75-90. Bird with fish, $45-65. (*Courtesy of Sunshine Studio, Santa Fe, New Mexico/Photo by Challis Thiessen.*)

Chapter 2

CARVERS AND CARVING

Old Masters and New: What's in a Name?

Before the 1900s, little is known about the carvers who produced these small sculptures. Artists did not sign their work for the simple reason that doing so goes against important cultural beliefs. Even today trying to establish authorship of pieces can be as difficult as corralling the wind, for Zuñi tradition discourages individuality in favor of community. The common themes emphasize working together, behaving properly and respecting both ancestors and spirits to ensure rain and continued harvests. Just like in large urban centers today, standing out courts disaster.

Speaking or exposing one's name is thought to reduce its "potency," handing over one's power to others. The Pueblo people's antipathy to mentioning death or the dead (lest they return) prohibits naming items which might later develop associations with dead persons or with enemies.

The work of carving is usually performed in the home, the labor shared among family members. Products are sold as they are made. Until the burgeoning of the market for their work, the small groups of carvers knew one another and their work; there seemed little need to identify them. Styles generated within families are thought to belong solely to them; copying without permission is a betrayal.

Within the Zuñi tribe, there are several dynasties of carving families. The first generation of carvers distinguished by name throughout the mid-twentieth century include Leekya Deyuse (1889-1966), Teddy Weahkee (?-1965), and Leo Poblano (1905-1959). Using hand tools, files and emery paper, they created traditional fetishes, stringing fetishes, figurines, and carvings set into jewelry. The pieces may appear less detailed or realistic than those of carvers working today, but their workmanship is part of their distinction.

Leekya, who instructed his children to use his first name as their last name when they went to school (to avoid confusion with other Deyuses), worked for trader C. G. Wallace and is best known for his necklaces, turquoise figurines, and carvings set into jewelry. Early carvings made for trade or sale by Leekya during the period 1920–1950 consisted mostly of representations of human figures in traditional dress, plant forms like leaves, or body parts like hands and feet. Characteristic of his forms are rounded curves, small, elegant ears, and the use of shallow incised lines to suggest other features.

Teddy Weahkee is best known for his traditional-style carvings, inlaid jewelry, turquoise human figures, carvings for jewelry, and paintings. Leo Poblano, famous for his carvings and his inlaid jewelry, worked primarily with traders Wallace and Woodard.[1] Authenticated works by these carvers, especially Leekya, are hardly accessible to the average buyer, commanding thousands of dollars in the current market.

The great value some of these early, hand-tooled pieces command encourages the production of fakes, especially since attribution is difficult. True to Zuñi tradition, these artists rarely signed their work. (Some Leekya necklaces do carry a silver tag denoting "LEEKYA.") Since styles developed within families are passed on to the following generation of carvers, identifying individual carvers can be very difficult. For this reason, some dealers identify pieces with family names, not individual ones.

Perhaps the most important legacy of the great carvers rests in their descendants who still carve today. Rodee and Ostler have prepared a genealogy of some of these families in their book, *The Fetish Carvers of Zuni*. (As you follow the lineages, keep in mind the fact that Pueblo cultures are matrilineal, that is, the lines of descent and identity are traced through the mother, not the father.) Many of the pieces identified in this book were produced by descendants of these past masters. From the Leekya line come the Homers; from Weahkee come Edna Leki, the Boones, the Gaspers, the Tsikewas, and the Hannaweekes, to name just a few. (See Pages 24-26 for examples.)

Even today there remain carvers and dealers who believe that the carver's signature is in the work he does, not in a name attached to it. Names can be counterfeited, traded, inherited, but craftsmanship cannot. The emphasis should be on the work not the name. Consequently, even when works are signed, they may reflect group, clan, or family affiliations rather than individuals, and initials are chosen that may represent more than one person. The spelling of some names may take several accepted forms, and marks or letters scratched into or written on a piece need not represent the artist at all. Instead these trademarks may represent traders, wholesalers, cooperatives, or guilds through which the piece has passed, or they may represent dealers' codes designed to help retailers with pricing.

From mid-century to the boom in 1985, thirty or so carvers, many descendants of the "Old Masters," continued the development of their craft. From this period come famous names George Cheechee, Michael Haloo, Leonard Halate, Theodore Kucate, Neil Natewa, Alice Leekya, and Mary and David Tsikewa, to name just a few. Their work is carried into the present through the work of literally hundreds of carvers—the Sheches, Quams, Quandelacys, Tsethlikais, Haloos, Peinas, Banteahs, Ponchos, Mahkees, Cheamas and many more—using improved technology to produce pieces in both traditional and modern styles. A partial list of carvers is included in Appendix A of this book. However, because carvers are not listed does not mean they are not worthy or that their work is not authentic. With more than 400 carvers currently working to produce more than 50,000 pieces a year, it would be impossible to list them all.

Methods and Materials

The modern world has brought new tools and new materials, yet authentic fetishes remain basically hand-worked, individualized art. Hand tools and pump drills replaced the prehistoric method of tapping hard stones with sharp ones and smoothing with sand. Today these have given way, in many cases, to motor-driven grinding wheels and diamond drills greatly increasing productivity and variety of carvings. The hand-held dremel and the expensive Fordham tools make possible the intricate detail, faceting, and precise inlay of contemporary works. Method has changed too; the necessity of changing wheels on machinery have made it expedient to work on several pieces at a time. After the work is planned, it can be executed in 10-60 minutes. Carver Gary Acque reports crafting 20-25 pieces a day (Rodee and Ostler 42-46, 58).

Traditional materials—turquoise, coral, bone, shell, antler, jet, wood, pipestone, Zuni stone—are still routinely used, even preferred by some carvers like the Sheche family. However, the range today includes a world-wide array of common and exotic materials reflecting the sophistication of today's carvers. Minerals include serpentine, marble, alabaster, dolomite, travertine, malachite, azurite, lapis-lazuli, sugilite, rhodo-chrosite, selenite, fluorite, zebra rock, nutria, lepidolite. Other natural materials include shells (mother-of-pearl, green snail, pink mussel, spiney oyster, clam, conus,

alivella, abalone, cowrie, etc.), amber, ivory (often fossilized walrus tusk and teeth collected and sold by the Northwestern tribes), deer and elk antler, cow horn and bone, ironwood, cottonwood, and cedar. Basically, the material used greatly affects the price of the piece. The more rare it is (purple sugalite, for example) or the more difficult to carve (hard like jasper, soft like amber) the more the piece will cost.

A Word About Turquoise

Turquoise, the stone most often associated with Native American art and jewelry, enjoys that status for several reasons. According to legend, there once lived a great chief with turquoise-colored skin. Pursued by his enemies into the desert, he sweated drops of turquoise throughout the landscape. By association with his suffering, these nuggets are precious. Turquoise, with its range of blues and greens, also represents the miracle of the earth, a mixture of sky and water. It is easy to see how its likeness to the earth (even without the benefit of satellite pictures from outer space) makes it a valuable, refreshing symbol of blessings, good fortune, and long life amid the buffs, browns, and muted reds of the Southwestern landscape. As such, highly prized by the Pueblo tribes, it is frequently worn as a display of wealth and a blessing for long life.

Nor are Native Americans alone in their reverence for this stone. It has a powerful history in European traditions as well. In the fourth century B.C. Aristotle recommended turquoise for scorpion stings and epilepsy, while thirteenth century German philosopher and teacher Albertus Magnus (teacher of Thomas Acquinas) sings its praises in his gem encyclopedia. Among other properties, this lovely stone cures the head and heart; helps night vision; wards off the evil eye; helps clairvoyants see the future; brings good luck, health, and happiness; and captures the hearts of lovers and defeated enemies. The mere sight of it induces laughter.[2]

Indeed, this esteem for turquoise and understanding of its association with the earth has a scientific basis as well. A miraculous combination of sky and water creates it. Even from the geologist's point of view, sky blends with stone in turquoise. Oxygen mixes with andesite, augite, feldspar, kaolin clay, aluminum, and traces of copper; from this seeding process, turquoise grains and crystals grow. Like the earth itself, turquoise can both hold moisture (it's porous) and dry out, initiating changes in color (Karasik, 10).

Turquoise was first mined by the Indians of the Southwest with stone hammers and deer antler picks. Fire was used to split the bedrock and follow the veins. Although there remain a number of turquoise mines in the Southwest, much of the turquoise used by Native American crafts people today is imported. That's one reason why turquoise fetishes tend to be more expensive than, say, serpentine carvings. Depending on its level of hardness, color, markings, cut and polished pieces can range from ten cents to ten dollars a carat. In general harder stones are preferred because they are less porous, less likely to change color when they come in contact with soap or body oils, and less likely to crumble in the process of working. In the Southwest stones showing the spider-web pattern of matrix are most prized. Matrix refers to the markings, lines, or blotches in which the mother rock shows through the surface of the stone (Bahti, 10).

Because of the difficulty in working turquoise stones, almost eighty percent of the turquoise on the market must be stabilized to be used. This process generally consists of soaking the softer, more porous stones in a plastic resin to improve its durability, decreasing its tendency to fracture or crack. This practice goes back a long way. Animal fat and tallow have been used for thousands of years to deepen the color of turquoise. Stabilized turquoise, with its transparent, shiny appearance, should be signifi-

cantly less expensive than good quality turquoise, so it's a good idea to learn to recognize it. Experts describe the treated version as "too blue" or "too shiny" compared to untreated stones. Watch out, too, for matrixes darkened by shoe polish. Ethical dealers and crafts persons will identify treated turquoise. Stabilized turquoise should be treated as costume jewelry, not the real gemstone, and priced accordingly (Branson, 4).

Notes

[1] For more detailed descriptions of the works of these carvers, see Kent McManis, *A Guide to Zuni Fetishes* (Tucson, Arizona: Treasure Chest Books, 1995): 34-38; Rodee and Ostler, 50-51; and Dr. Harold Finkelstein, *Zuni Fetish Carvings* (Decatur, Georgia: South West Connection, 1994):12.

[2] Carol Karasik, *The Turquoise Trail: Native American Jewelry and the Culture of the Southwest*. New York: Harry N. Abrams, Inc., 1993.

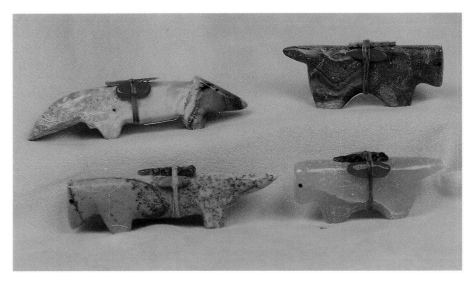

Four Zuñi fetishes in Sheche family style. All have arrow point, turquoise and coral nuggets in their medicine bundles. Top left: white wolf by AS, $30-40; top right: travertine wildcat, $20-30; bottom left: spotted serpentine coyote $25-30; bottom right: red quartz wildcat, $20-30. (*Courtesy of Adobe Gallery, Albuquerque, New Mexico.*)

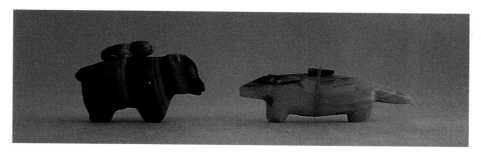

Left: This beautiful, banded serpentine bear with its large turquoise bundle and delicate ears is vintage Leekya (Zuñi), $1,500-2,000-plus, could go higher. Right: The elongated form of this wolf fetish was fashioned from pink shell by Zuñi master carver Leo Poblano, $600-900. (*Courtesy of Sunshine Studio, Santa Fe, New Mexico/Photo by Challis Thiessen.*)

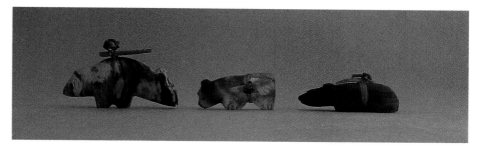

Carvings by the Weahkee family. Left: Serpentine fox by Edna Weahkee Leki, daughter of Teddy Weahkee, carries a shell point bundle adorned with coral and turquoise, $60-75. Center: Lena Boone, daughter of Edna Leki, carved this fluorite mountain lion in traditional style, tail following the line of the back, $40-65. Right: This handsome mole of Indian paint rock was carved by Leki's grandson, Leland Boone, fourth generation fetish carver. $35-50. (*Courtesy of Sunshine Studio, Santa Fe, New Mexico/Photo by Challis Thiessen.*)

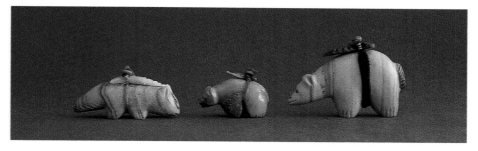

Other Weahkee family carvers: Left: Traditional style wolf, carved of dolomite by Teddy Weahkee's daughter, Edna Leki, bears a turquoise nugget bundle, $60-75. Center: This smaller, turquoise bear was carved by Leki's daughter, Debra Gasper, $55-65. Right: Dinah Gasper, granddaughter of Edna Leki, carved this dolomite bear, $50-60. (*Courtesy of Sunshine Studio, Santa Fe, New Mexico/Photo by Challis Thiessen.*)

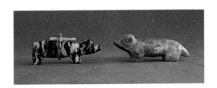

Two generations of the Tsikewa family. Left: Bear of zebra rock, carved by Bill Tsikewa, Sr., son of Mary Tsikewa, $50-70. Right: Serpentine ram carved by Mary Tsikewa, $75-100. (*Courtesy of Sunshine Studio, Santa Fe, New Mexico/Photo by Challis Thiessen.*)

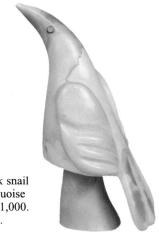

Large Dove, 5.25", was carved of pink snail shell by Zuñi artist Neil Natewa. Turquoise inlay eyes. Signed by the artist. $800-1,000. (*Courtesy of the Estate of Katherine L. Fitch.*)

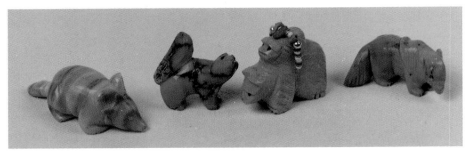

Left to right: banded serpentine mouse with turquoise eyes, 2", $35-40; turquoise squirrel, 1", $40-45; turquoise bear with cub on back, 1.5", bundle has coral, turquoise, silver, and heishe beads, $50-65; turquoise wolf, 2", $45-55. (*Courtesy of Kiva Indian Trading Post, Santa Fe, New Mexico.*)

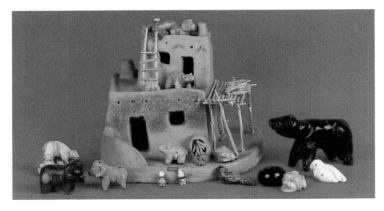

House for fetishes. Animals, wild and domestic, as well as birds and a few humans, find an adobe home here. Look at all the lovely shades of turquoise. (*Courtesy of The Turquoise Lady, Albuquerque, New Mexico.*)

FETISH FEATURES

Heartlines

Many fetishes have an etched, painted, or stone-inlaid heartline along one or both sides. Varying in length, it extends usually from the nose or mouth of the animal and ends in a point, like an arrowhead. Although it is rarely seen in the earliest fetishes, when it does appear the line usually extends from the mouth all the way to the rear or anus. (See photo, Page 17) It serves as a reminder of the biological functions once performed by the spirit preserved within the fetish.

The heartline may also recall elements from the Zuñi emergence story mentioned earlier. It celebrates the lightning arrows shot by the Warrior Twins. Those arrows turned to stone the fierce animals threatening the human emergence from the dark under-worlds. It may also represent the path which connects the breath of the animal to the living heart or life force within. In fetishes used for hunting, the heartline symbolizes the control the prey gods exert over the hearts of the hunted. The arrow tip or point at the end shows the passage of power or the creative spirit as it metaphorically pierces the heart of the victim. At the same time it reenacts the actual hunt with bow and arrow.

Another theory suggests that this line represents the healing or curing powers of the fetish. In the Zuñi religion, where relatedness is manifested through resemblance, the "heartline arrow" recalls both the snake and lightning, two extremely powerful forces in their cultural mythology.

Medicine Bundles

The arrowhead or point may appear as well in another feature of some fetishes, the medicine bundle. The medicine bundle consists of arrowheads, stones, shells, or feathers tied to the back, side or belly of the carved figure. Once secured with sinew, now the bundles are generally attached with beading thread. Like the heartline, the bundles on today's carvings, unless invested with blessings or belief, are purely ornamental. However, among believers they are added to increase the power of the fetish or to express gratitude for blessings received or anticipated. Veneration of the fetish honors the spirit of the animal within.

The ornaments which make up the bundle are charged with meaning as well. Points or arrowheads tied to the back, once again using the notion of relation and resemblance, invoke the power of the bow and arrow. Related in form to the rainbow and lightning, they call upon the powers of nature to protect the bearer. Arrow points (also called arrowheads) resemble the sharp, deadly fangs of the snake, a very potent emblem in Pueblo mythology. Placement of the arrow point has special significance on fetishes of war. Bound beneath the belly or feet of the fetish, it summons the ability to hide one's tracks, to baffle pursuit. Secured to the back of the animal, arrow points call upon the same power to protect the bearer from unexpected attack. At one time the points attached to fetishes were arrowheads found among the ruins of canyon habitations; now they are generally carved of shell.

Other items which appear in bundles assert other powers. Bits of red coral or red stone may signify the heart of the fetish, entreating its curative powers. Blue stones or turquoise may recall the essential blending of sky and water. The colors yellow, blue, red, white, speckled, and black signify the predominant colors assigned to the six directions: north, west, south, east, upper and lower regions of the world, respectively.

In literature accompanying his carvings, Andy Abeita of the Isleta Pueblo offers a slightly different rendering of meanings lodged in the bundles. Coral recalls the life of the ocean, blue the sky, black the life of the night, brown the things of the earth, white for winter, and feathers invoke all the colors of the sky. Since feathers carry very powerful religious messages in their religion, Zuñi carvers rarely attach them to carvings made for the general market.

Fetish Jars: Feeding and Caring for Fetishes

Because fetishes are said to house the living spirit of the animal they represent, they must be cared for and fed as a living creature to ensure their efficacy. Owned individually or communally, each requires a reliable caretaker. Worn, carried, or displayed when in use, they may be kept in a fetish jar or pot when idle.

These pots may be decorated for particular uses. In her study of fetishes, Ruth Kirk inventories all manner of fetishes (hunting, Shalako rain fetishes, society, witchcraft punishment, weather and snake bite sets, war medicine sets, fire-making sets, gambling and betting sets), many of which are housed in corresponding pots or jars. Over the years, pots may be reused, housing different kinds of fetishes. However, usually only one kind of fetish will inhabit the pot at any one time.

In fact, it is the existence of the pots which finally convinced anthropologists that fetishes were in use prior to the time of Spanish occupation (roughly 1650-1850). Few fetishes can be documented before that time because Spanish missionaries systematically destroyed the Pueblos' religious artifacts. However, pots remain that antedate the Spanish conquests in the late seventeenth century, even if few of their larger-sized fetish inhabitants do.[1]

Handmade of clay, 12" high with a diameter of 14-16", they might be plain or decorated; in the more rare, older pots, the designs might be covered over by flecks of turquoise or shell which could be scraped off and brewed as a cure for tuberculosis or other ailments (Kirk, 20-23).

The fetish pots available for sale today are modern reproductions of these earlier pots, produced specifically for the collector's market. (Photos on Pages 32-33) In fact, evidence suggests that by the end of the nineteenth century tribes produced "special" jars just to satisfy the demands of early collectors and visiting ethnologists (Bahti, 17). The real jars pictured in Kirk's book, like the well-used old fetishes, bear little resemblance to the charming pieces produced for today's market. Stained with blood offerings and dirt, they look fierce and smell gamy. In spite of their unsavory appearance, authentic old fetishes and pots must be preserved in their original condition to keep their value.

The jars come in many shapes, the most common of which reproduces the shape of the *olla* or water jar. A half-bowl might also be used; half-bowls with terraced edges were called *cloud bowls*. When not in use, the fetishes lived (some still do) inside the pot on a bed of down, corn pollen, and wood ash, their faces turned toward a 1- 4" hole low on one side of the jar through which they breathe and eat. (Mole fetishes are usually kept in small, rawhide bags in the pots because they prefer darkness. Bird fetishes may be suspended from the top by a piece of sinew.) Correctly positioned, the hole faces east in the direction of the rising sun. If the jar has no feeding hole, like birthing

jars, it may be laid on its side so the fetishes can receive care. The skin of a ceremonially killed deer weighted down by a rock may cover the top. Sometimes directional or other special fetishes tied to the outside of the jars guard the openings and protect the fetishes inside.

To feed the fetishes, food is placed in a dish or on a piece of paper beside the fetish or jar. The spirit of the food offering nourishes the spirit of the fetish. After 15-30 minutes, the offering can be removed. Used food should be buried or thrown into the river. Apparently it cannot be burned or fed to another because its soul has gone, its nourishment depleted. Reusing sacrificial offerings would offend the spirits of the fetishes.

Notes

[1]Kirk cites the work of Dr. H. P. Mera, ceramic expert at the Laboratory of Anthropology in Santa Fe in *Zuni Fetishism*. (Albuquerque, New Mexico: Avanyu Publishing, Inc., 1988): 21.

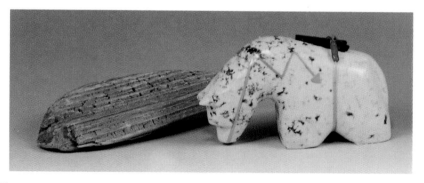

Yellow serpentine bear, 4", by Zuñi artist Tony Laiwakete. $50-65. (*Courtesy of Tumbleweed Trading, Manayunk, Pennsylvania.*)

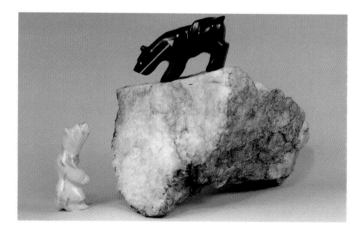

Left: Stone bear, 2", by Barney Calavasa (Zuñi), $45-55. Right: Mountain lion, 2.5", of jet with turquoise inlay heartline. Made by Andres Quandelacy (Zuñi). $90-100. (*Courtesy of Tumbleweed Trading, Manayunk, Pennsylvania.*)

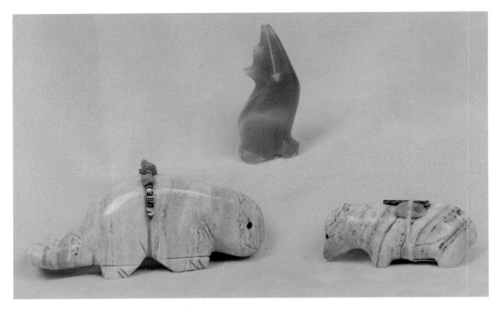

Three Zuñi fetishes. Top: fluorite howling coyote, 2", with turquoise inlay heartline. By Rhoda Quam of Zuñi, $75-90. Bottom left: Serpentine beaver with medicine bundle of heishe beads, coral, and turquoise, $65-75. Bottom right: Serpentine bear with arrow point, turquoise and coral nuggets in bundle. Probably Sheche family, $40-50. (*Courtesy of Adobe Gallery, Albuquerque, New Mexico.*)

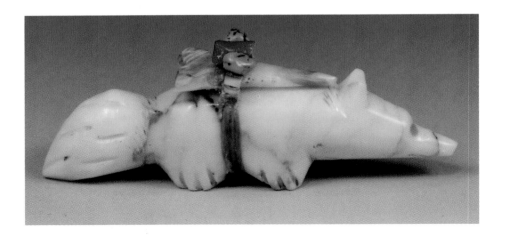

Terrific white alabaster wolf, 2.5", fashioned by Edna Leki (Zuñi). Wolf carries a medicine bundle of shell, coral, turquoise, and heishe. Turquoise eyes. Part of directional set. Wolf: $40-50. (*Courtesy of private collector and Adobe East Gallery, Summit, New Jersey.*)

Mountain lion carved of alabaster has elaborate feathered bundle, including shells, jet, coral, turquoise. Three stones including lapis in heartline. Turquoise eyes. Work of Andy Abeita (Isleta). $75-85. (*Courtesy of Palms Trading Company, Albuquerque, New Mexico.*)

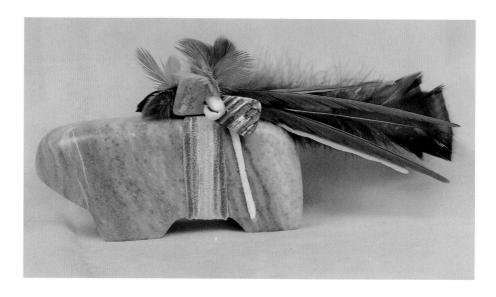

Large stone mountain lion, 6", in the characteristic style of Mark Swazo Hines (Tesuque). Very colorful medicine bundle of rawhide, large pieces of shell and turquoise, lots of feathers. $230-250. (*Courtesy of Adobe Gallery, Albuquerque, New Mexico.*)

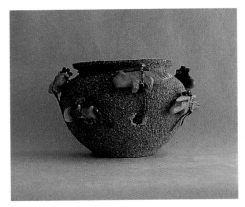

Turquoise-studded fetish jar, 6" diameter x 4" tall, by Edna Leki (Zuñi). Eight fetishes, tied on with sinew, guard the outside of the jar. Two fetishes housed inside. Feeding hole in lower front. (*Courtesy of Sunshine Studio, Santa Fe, New Mexico/Photo by Challis Thiessen.*)

Birds-eye view inside Leki fetish jar with cornmeal mixture and two fetishes. (*Courtesy of Sunshine Studio, Santa Fe, New Mexico/Photo by Challis Thiessen*)

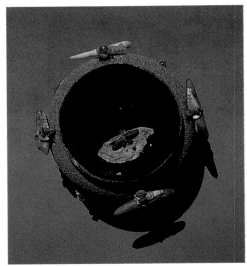

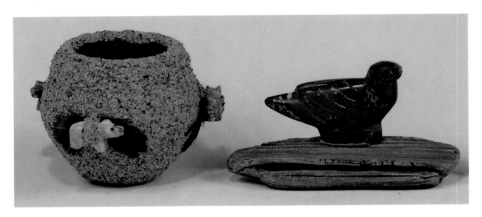

Clay pot, 4" x 3", dusted with crushed turquoise chips and guarded by four bears, each with feather bundle. No feeding hole in this pot. $85-95. Right: Old-style bird, 2", with "X" etched on back to represent folded wings. Carved of lapis with coral inlay eyes by Sheche family. $45-55. (*Courtesy of Tumbleweed Trading, Manayunk, Pennsylvania.*)

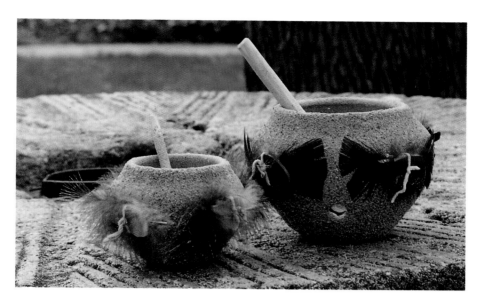

Two fetish pots. Left: small fetish jar, 3" x 4.5", guarded by four, feathered stone bears. Crushed turquoise covers clay pot and stick. No feeding hole. $65-75. Right: Large clay jar, 4.5" x 6", with crushed turquoise outside. Guarded by four pipestone bears. Feeding hole in side. One bear fetish resides within on bed of cornmeal and wood ash. Turquoise-dusted stick ladder included. $85-95. (*Courtesy of Eicher Indian Museum Shop, Ephrata, Pennsylvania.*)

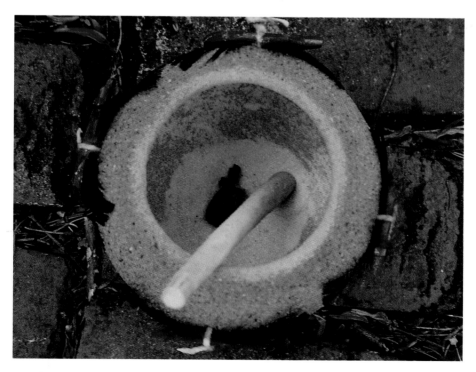

Top-view inside large fetish pot. Bear rests on cornmeal and wood ash mixture. (*Courtesy of Eicher Indian Museum Shop, Ephrata, Pennsylvania.*)

ANIMAL GUARDIANS
OF THE SIX DIRECTIONS

Various tribes of the Southwest, particularly the Zuñi, define their world and direct their lives in terms of a directional system which places their village and its inhabitants at the center of the universe. This system also places humankind in "correct" relation to the highest divinity, the Sun-Spirit. Its daily east-west passage and annual north-south movement establish those directions. Add the upper and lower dimensions and the Pueblo sits snug at the "Middle Place," its inhabitants securely oriented to their proper position in the world.

From each of the six directions flow the supernatural powers directed to the Pueblo center through designated colors, gods, animals, birds, maidens, trees, snakes, butterflies, cloud spirits, and even warriors associated with it.[1] Since food and rain are the most important conditions for survival in the austere landscape of the Southwest, many of the evolving symbols are closely linked to the acquisition of food or the food chain.

Of this array of directional guides, the animal gods are most frequently represented in fetishes. Special colors designate the most powerful animal gods for each direction. In the old stories, the Great Father of the Medicine Societies, *Po-shai-an-kia*, lived with his children at the center of the world, guarded on each of six sides by a sacred animal. At the top of the hierarchy (hence most powerful) reigns yellow Mountain Lion, set to guard the Northern region. Counter-clockwise from there around the Middle Place (which just happens to be Zuñi) follow blue Bear, Guardian of the West; red Badger, Guardian of the South; white Wolf, Guardian of the East; multi-hued Eagle, Guardian of the Upper Regions; and black Mole, Guardian of the Lower Regions.

Beginning with the mountain lion, each is considered the younger brother of the one before; thus Bear is younger brother to Mountain Lion, Badger is younger brother to Bear, Wolf to Badger, and so on. Each animal holds the medicinal powers of its region and carries messages from humans to the Great Father. As mediator and healer, the animal's fetish counterpart is honored and appeased by priests in sometimes elaborate rituals. During initiation ceremonies, candidates choose a direction and guardian as their special protectors.

To further complicate matters, each species has its own series of younger brothers. For example, again counter-clockwise around the circle, yellow Mountain Lion has blue (West), red (South), white (East), multi-hued (Upper), and black (Lower) younger brothers. As designate of the North, yellow Mountain Lion wields the most power. In the same way, blue Bear of the West precedes in strength his red, white, multi-hued, black, and yellow younger brethren. So goes the pattern through Badger, Wolf, Eagle, and Mole.

Collectors try to acquire complete sets of the animal directional guardians. Sometimes they group favorite pieces by different artists into directional sets. However, some artists do carve and sell complete directional sets, featuring appropriate animals and colors.

Notes

[1]In *Pueblo Birds and Myths*, Tyler Hamilton explains that these directions do not directly correspond to the directions indicated on a compass since Pueblo Indians use the sunrise and sunset of the longest and shortest days to designate directions. That system would indicate northeast and northwest, southeast and southwest as cornerstones of the world, with midpoints of the rectangle reflecting the cardinal or compass directions.

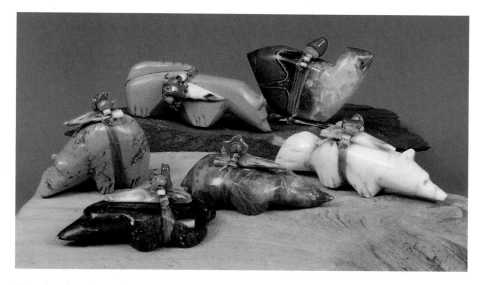

Directional set by Zuñi artist Edna Leki. Counter-clockwise: Zuñi stone mountain lion, north; turquoise bear, west; red marble badger, south; alabaster wolf, east; septarian eagle, zenith; black marble mole, nadir. $180-200/set. (*Courtesy of private collector and Adobe East Gallery, New Jersey.*)

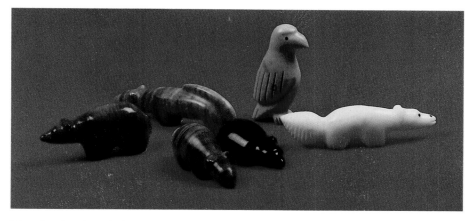

Directional set by Dinah Gasper (Zuñi). Left to right: stone bear, west; serpentine mountain lion, north; serpentine badger, south; jet mole (nadir), Zuni stone eagle, zenith; alabaster wolf, east. $240-260/set. (*Courtesy of Andrews Pueblo Pottery and Art Gallery, Albuquerque, New Mexico.*)

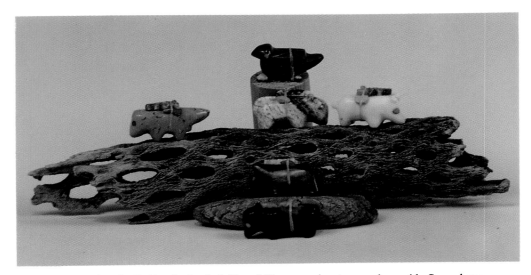

Directional set by Zuñi artist Jessie LeBoeuf. Top row: pipestone eagle, zenith. Second row, left to right: turquoise bear with coral eyes, west; serpentine mountain lion, north; alabaster wolf, east. Third row: pipestone badger, south. Bottom row: jet mole, nadir. $245-265/set. (*Courtesy of Tumbleweed Trading, Manayunk, Pennsylvania.*)

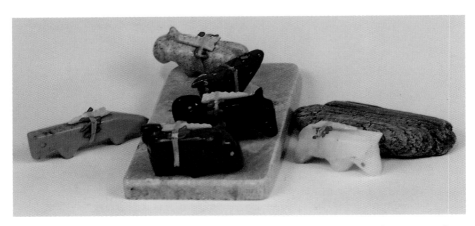

Directional set by Sheche family (Zuñi). Left: turquoise bear, west. Back to front: serpentine mountain lion, north; pipestone eagle, zenith; jet mole, nadir; pipestone badger, south. Right: alabaster wolf, east. $150-170. (*Courtesy of Connie Medaugh.*)

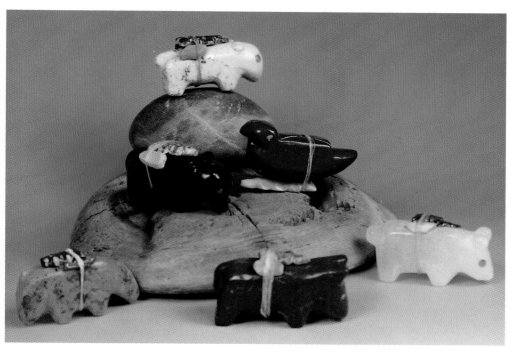

Directional set by Lorandina Sheche (Zuñi). Top: serpentine mountain lion, north. Middle: jet mole, nadir; pipestone eagle, zenith. Bottom: turquoise wolf, east; pipestone badger, south; alabaster bear, west. $210-230. (*Courtesy of Fitch's Trading Post, Harrisburg, Pennsylvania.*)

Chapter 5

HUNTING FETISHES: PREY GODS OF THE HUNT

Within the Zuñi tradition a slightly different configuration of special animal spirits assists humans in the hunt. These animals spirits, called Prey Gods, number among the most frequently carved fetish images. Like the Directional Guides, they display color and directional distinctions. In fact, with the exception of Bear and Badger, replaced by Coyote and Wildcat, the animal gods are the same: North, yellow Mountain Lion; West, blue Coyote; South, red Wildcat; East, white Wolf; Zenith, multi-hued Eagle (sometimes Red-tailed Hawk); and Nadir, black Mole. How each of these animals came to earn their particular assignment can be found in Zuñi legend.

In the earliest days, the Snail People used magic to gather together all the game animals, penning them within a hidden canyon. Rain and floods were sent to wash away their tracks, and the rest of humankind languished for food. The canyon was found by the Shalako, a monstrous being combining human and bird forms, who magically opened it. As each species of game emerged, the Shalako assigned a predator animal to subdue it, establishing a linkage between those animals henceforth. The mountain lion was sent to slay the elk, deer, and bison who galloped towards the white mountain of the north; the coyote (after a few predictable problems) pursued the mountain sheep, who fled towards the blue western mountains. After that came the wildcat, who headed south to tackle the antelope; the wolf chased the O-ho-li (white antelope or white-tailed deer) eastward; the eagle snatched the jack rabbit from above; and the mole trapped beneath the earth any small game who tried to escape down there. (Cushing mentions the mole getting some assistance with mice and rats from the ground owl and the falcon.) Not surprisingly, the Snail People, angered by the interference, declared war on humankind.

Fetish representations of these predators or Prey Gods may be carried by individual hunters depending on the kind of game they seek. Special society rituals also solicit and celebrate the assistance of these animal spirits in successfully tracking, killing, and honoring the game animals upon whose sacrifice their lives depend. In one part of the prescribed ritual, the human hunter breathes from the nostrils of the fetish, then exhales that breath in the direction of the game he seeks. Since the living hearts of the predators inhabiting the fetish have power over the hearts of the game animals, they charm the senses of the hunted and prevent their escape. The preferred method of killing (and also, I suppose, the most difficult) is smothering. This method keeps the breath within the beast, retaining the "life principle" and facilitating its rebirth (Tyler, *Pueblo Animals*, 86).

Proper use of the fetish in prescribed rituals ensures the return of the slain animal to Kachina Village, where it can be reborn again and again into the world, guaranteeing a continuous supply of game. One of the most important parts of the ritual involves the "breath of life," which some say is depicted in the heart lines etched or inlaid into the sides of some fetishes. To enact "the breath of life" the hunter puffs tobacco smoke into the nostrils of the beast, inhaling its last breath. In another part of the ritual of thanks,

the fetish is rewarded for a successful hunt by a ritual bath in the blood of the victim. With each success, its powers grow (Kirk, 30).

As masters of the north and west, Mountain Lion and Coyote are considered the most powerful prey fetishes. Their special prey are deer and mountain sheep, respectively. A hunter pursuing either game would be sure to carry the correct fetish. By the same token, a hunter stalking rabbits, for example, might choose to carry an eagle or mole fetish instead.

The worship of prey beings is concentrated during winter solstice. Fetishes are cleansed and placed on altars in ritual order based on meaning and color. Bird forms may be suspended by strings above the altar. Prayers and blessings renew both the strength of the fetish and the hunters who use them.

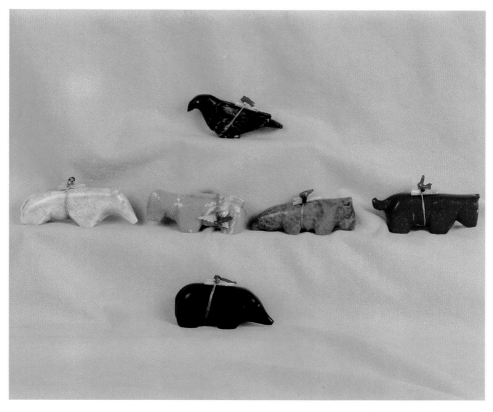

Prey Gods by Lorandina Sheche (Zuñi). Top: moss serpentine eagle, zenith. Middle, left to right: alabaster wolf, east; serpentine mountain lion, north; turquoise coyote, west; pipestone wildcat, south. Bottom: jet mole, lower. $180-225. (*Courtesy of Turquoise Lady, Albuquerque, New Mexico.*)

Picasso marble jack rabbit with turquoise eyes, 1.75". By Celester Laate. $35-40. (*Courtesy of Turning Point Gallery, Media, Pennsylvania.*)

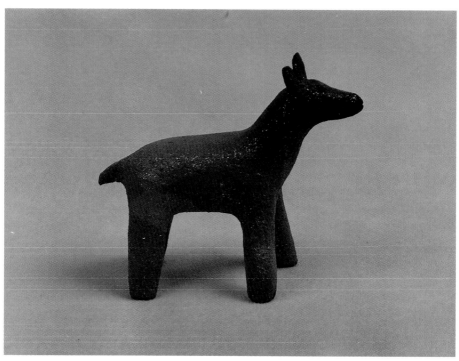

Deer fetish of micacious clay. From Pojoaque Pueblo; carver unknown. (*Courtesy of private collection.*)

41

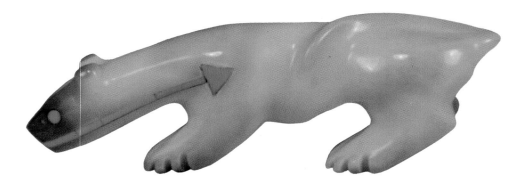

Yellow Mountain lion or Puma, 2", Prey God of the North. Fossil ivory with turquoise inlay eyes and heartline. By Zuñi artist Andres Quandelacy. $85-95. (*Courtesy of private collection.*)

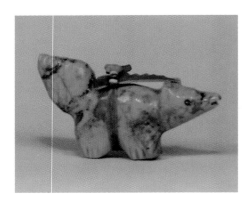

Blue Coyote, 1.5", Prey God of the West. Features coral inlay eyes and full bundle. Arrowpoint is spiney oyster with shell, coral, and turquoise attached. Traditional style of Weahkee/Boone/Gasper family. $50-65 (*Courtesy of Turning Point Gallery, Media, Pennsylvania.*)

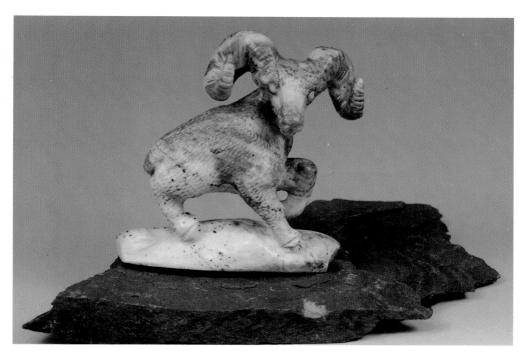

Mt. Goat, 3". Picasso marble with turquoise inlay eyes. Carved in lovely detail by Wilford Cheama (Zuñi). $375-400. (*Courtesy of Ian M. Schwartz, Adobe East Gallery, Summit, New Jersey.*)

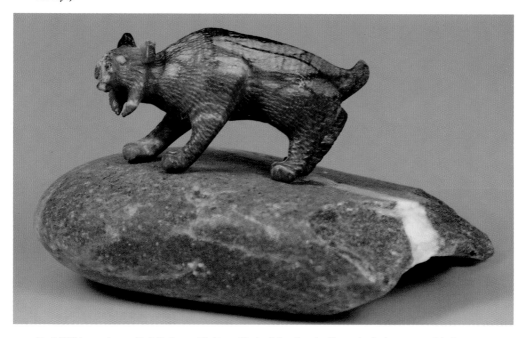

Red Wildcat, also called Bobcat, 3", Prey God of the South. Carved of picasso marble in lifelike pose by Zuñi artist Wilford Cheama. $195-220. (*Courtesy of Ian M. Schwartz, Adobe East Gallery, Summit, New Jersey.*)

Ibex or mountain goat, 3". Carved of antler by Pernell Laate of Zuñi. $135-150. *(Courtesy of Turning Point Gallery, Media, Pennsylvania.)*

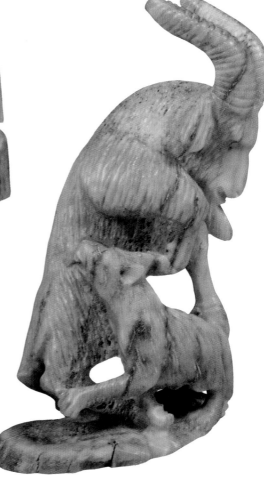

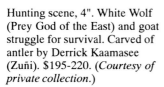

Hunting scene, 4". White Wolf (Prey God of the East) and goat struggle for survival. Carved of antler by Derrick Kaamasee (Zuñi). $195-220. *(Courtesy of private collection.)*

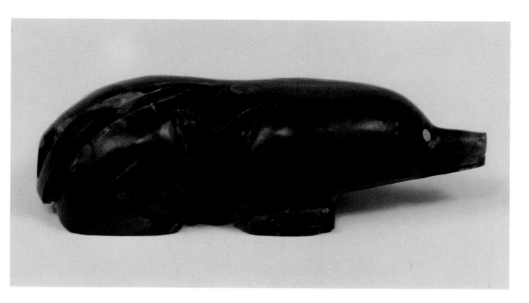

Black Mole, 2.75". Prey God of the Lower Regions. Carved of picasso marble by Alex Tsethlikai (Zuñi). Turquoise eyes. $50-60. (*Courtesy of The Turquoise Shoppe, Lititz, Pennsylvania.*)

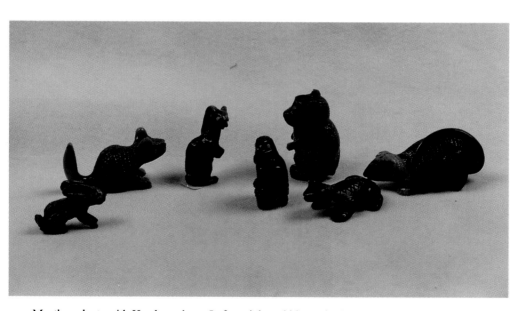

Mostly rodents with Hawk predator. Left to right: rabbit, squirrel, weasel, hawk, ground squirrel, frog, and rat. All carved of green serpentine by Dan Quam. $50-100 each. (*Courtesy of Southwestern Indian Art, Inc., Gallup, New Mexico.*)

45

Hawk, 2.5". Carved by unknown artist of green snail shell. $100-120. (*Courtesy of private collection.*)

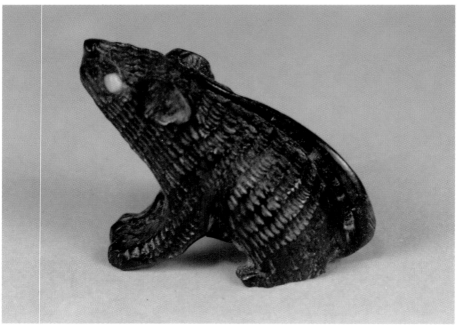

Jet mouse, 1". By Lance Cheama of Zuñi. $60-65. (*Courtesy of Turning Point Gallery, Media, Pennsylvania.*)

PAW-FOOTED BEINGS

Mountain Lion

The mountain lion figure represents great power in the Zuñi tradition. Mountain lion, called "Long Tail," is traditionally depicted as mostly body and head, with small knobs for feet and small, round ears. The most recognizable characteristic of this fetish, however, is the long tail (hence its name) which lies parallel along the ridge of the animal's back nearly to its shoulders.

Keeping to itself and rarely seen, the solitary mountain lion radiates a sense of mystery. And mystery, as we have seen, generates power. For this reason, the mountain lion is considered one of the most powerful animal spirits, elder brother to the other directional and prey god animals.

Although the yellow mountain lion serves as directional guardian and prey god of the north, its many-colored "little brother" of the upper regions plays a prominent role in war. Warriors of the Bow Priesthood entreat its aid in battle. Another brother, blue Mountain Lion, joins Red Ant at curing ceremonies of the Red Ant Society, charged with healing skin diseases.

A master hunter, strictly carnivorous, who roams a wide, well-defined territory, the mountain lion spirit is variously associated with personal power and resourcefulness, independence, leadership, spiritual intensity, intuition, fierce protectiveness, and loyalty. Through its fetish, the power of the mountain lion may be called upon to protect travelers (McManis, 9). It also oversees contests or activities that test one's skill or prowess. In the pueblo of Isleta, the lion (along with the bear) is thought to affect gambling activities (Tyler, *Pueblo Animals*, 213).

Bear

Called "Clumsy Foot" in Cushing's account of Zuñi fetishism, the bear as traditionally represented sports a distinctive nose, small ears, a rounded body, and very small tail. As Guardian of the West, the blue bear, eldest brother to all other bears, is associated with great strength, power, and healing. In fact, among the Zuñi, members of the Bear Clan or Society accept and enact special responsibility as healers. The link between bears and healing may be by association; that is, their coming and going is linked to seasonal changes which bring cold and snow, warmth and sun, and the diseases which accompany them.

The white bear of the upper regions, also credited with great medicinal powers, joins the mountain lion and the Knife-feathered Monster as representative spirits of the Priesthood of the Bow, playing important roles in scalp-taking ceremonies. Because of its ferocity and healing powers, the bear exerts a powerful protection against witches, who bring disease among the people.

Bears rank among the most popular fetishes with carvers and collectors alike, perhaps because we resemble each other in many ways. We both walk upright in "plantigrade" position, that is, rolling our weight across the entire foot from heel to toe. Both

fight in an upright position; in fact, unlike most other animals, the bear stands upright to challenge a human. With separate bones in their forearms just like humans and similar musculature, many of the bears' upper body movements greatly resemble human movement, especially when eating and digging. Moreover, like most humans, bears register and exhibit a range of emotions and moods which are readable from both countenance and posture.

It is this likeness to humans that makes bears such powerful mediators between the gods and humans. Even outside Pueblo traditions bears are protectors. In the beds of our children, teddy bears comfort and mediate between our little ones and the dark, frightening forces of the night. So like are bears to humans that, among the Zuñi, killing a bear is akin to killing a human. That is, individuals who kill bears must join the Warrior Society, performing rituals like those prescribed for persons who have killed humans.

On rare occasions, mostly when their pelts are needed, bears—like mountain lions and eagles—may be treated as game animals and hunted. The meat is eaten, but the skin is treated with great ceremony, just like scalps. In Isleta Pueblo, however, killing a bear breaks a tribal taboo, while the Navajo will not hunt bear unless facing abject starvation. Among Native American symbolic designs, the bear track or paw symbolizes power.

Badger

The badger, or "Black Mark Face," traditionally carved flat or low to the ground with sharp nose and thick tail, is recognized as the dominant spirit of the South, its color red. Yet it also has a mythological significance which differs from that of most other creatures who began life upon the surface of the world. The badger, it seems, actually helped humankind ascend from the four layers of the underworld to the surface.

Linked to both fire and curing, the badger's prodigious digging takes him into the realm of medicinal and fire-starting roots. In fact, among the Zuñi, historically the Badger Clan was charged with fire-making responsibilities. This relationship to fire has less to do with the red heat of summer than with the sun, so the badger plays an important role in rituals of the winter solstice.

The badger also serves as a good example of the cultural variety among neighboring Southwestern Pueblos. Although it is associated with curing among the Zuñi and other Pueblo peoples, it reigns as the dominant curing spirit among the Hopi, replacing the bear in that capacity. So effective, in fact, are the healing properties of badger grease that in the past it enjoyed an enthusiastic following in England as an ointment for strains and sprains (Tyler, *Pueblo Animals*, 15).

Associated with the Southern direction, the Red Badger dominates the activities of husbandry and agriculture attributed to that direction. Its track or paw print may be used as a design to suggest summer.

Relatively small but fierce and tenacious, the badger has been known to attack and prevail over animals far larger. As such, it can be counted on in tight situations to display boldness and perseverance making it a surprisingly powerful animal ally.

Wolf

In its earliest representations, the wolf or "Hang Tail" (white-colored Directional Guardian and Prey God of the East) appears standing upon four legs, its ears alert and upright in an oblique face, and its tail dropped below the level of its back. Rarely depicted in the howling position popular today, it is nonetheless difficult to tell apart from the coyote figure whose tail is usually slightly less bushy.

Intelligent, curious, social, and savage, the wolf brings power to endeavors of war and curing as well as the hunt. Moreover, its communal life and ability to cooperate with other pack members render it particularly successful against large prey which move in herds, such as elk, buffalo, and the albino antelope prescribed for it by tradition.

Perhaps because of its pack behavior, the wolf spirit represents not just successful hunting, but also the ability to work together for the good of the group. Mated pairs stay together for life. Both genders take active roles in feeding and protecting both pups and pack. In fact, some wolf fetishes are carved in pairs, sometimes from the same piece of stone, sometimes from two different stones bound tightly together. These fetishes, given to newlyweds, invoke for that couple the strong family bond exemplified in wolf pairs and pack.

Coyote

As Hunter God of the West, the eldest coyote brother dons a coat of blue. It replaces the blue bear who represents the West among the Directional Guardians. Unlike the howling position in which they are frequently shaped today, traditional-style coyotes display a small, pointed snout and erect ears. The tail either extends horizontally out from the line of its back or droops slightly.

Extremely fertile, omnivorous, and capable of thriving on very little water, the coyote is a survivor. That's essential because his impetuous behavior leads him often into error. Cursed with what Tyler describes as a kind of "antisocial stupidity," Coyote too frequently ignores the most important rules of communal society: to hunt only when hungry and to share his kill. Though the early-world saga of the hunt links him with the mountain sheep in a predator/prey relationship, he typically fails to bring down his quarry. Hence, he must scavenge for his food or settle for easier, more plentiful prey like rabbits. Coyote's intelligence is never questioned, but his judgment is. A great teacher, Coyote and his mistakes illustrate the evil which results from failure to follow the rules.

Among the Pueblos, the coyote is a complicated figure linked with good and evil. Associated with death because he eats dead things, he is also noted for his transformations. Like Raven and Owl, Coyote can turn seed into food, softening the corn kernels so that humans may eat them. Again, like Raven and Owl, Coyote also may damage the corn crop, which must be guarded against him.

In myths and tales, Coyote sometimes hunts with Badger. Apparently Coyote scents the prey and chases it. Badger digs it out if it goes to ground. According to Tyler, modern zoologists have also observed this partnership, but he doesn't explain if or how they share the resulting meal!

At Zuñi, the coyote is respected for his knowledge and for his survival skills, if not always for his actions. Perhaps in his intelligence, craft, and endurance, as well as his fallibility, he mirrors our own complexity, recalling the old adage: "Do what I say, not what I do." So honored is the coyote, in fact, that the Coyote Clan of Zuñi bears the important responsibility for teaching both hunting skills and ceremonial respect for game.

Wildcat

Among the Hunter or Prey Gods, Wildcat (also called Bobcat or Lynx) dominates the Southern Region. Its color is red, like the badger who holds that position among the Directional Guardians. Traditional wildcat fetishes are rare, distinguished by short bodies, short tails held straight out from their bodies or curving upward just the slightest bit. Their flat faces are carried perpendicular to the ground with short, erect ears. They may be confused with traditional-style coyote figures, whose ears may be longer and more erect and whose tails are usually slightly thicker and longer. Several contemporary carvers (for example, Wilford Cheama, Dan Quam, and Michael Coble) now produce wonderfully detailed wildcat figures. Mythologically, the wildcat is linked in a special predator/prey relationship with the antelope. Like its larger, more powerful and far-ranging elder brother, the mountain lion, the wildcat is both elusive and intelligent, a solitary and independent hunter.

Mole

Because the mole, the Hunter God of the Lower Regions, was thought to wield less power than the other spirit guides, it was less frequently carved in the past. Older versions, often rudely carved, depict a sharp-nosed, squat creature with a thin, often stubby tail. The current interest in and demand for complete directional sets has brought mole figures back into production. Abby Quam's stylish contemporary version is especially popular.

As Spirit Guardian of the Lower Regions, the mole protects the crops from disease at their roots. As black Hunt God it burrows after and destroys mice, rats, or other small animals whose appetite threatens the harvest. Hunters might ask Mole to rearrange underbrush or soften the earth to slow the flight of their prey. Mole can tap into and release the energy of the earth. Thus it uncovers the secrets of herbs, roots, minerals, seeds, rivers, and other treasures hidden there.

Fox

Frequently carved with a narrow face and very bushy tail, the fox represents cleverness and craft. In a story from the Acoma Pueblo, fox subverts man's plan to have animals sacrifice themselves without the effort of hunting. White Light Woman, conjured by humans from an ear-of-corn fetish, acts like the Greek siren, luring all animals to her and killing them before they realize the danger. Clever fox hides within the carcass of a dead deer and witnesses the scheme. (For this reason, in Acoma, the ribs of the deer are called the "window of the fox.") Fortified with this knowledge the fox warns all the animals to run in the opposite direction when White Light Woman calls, advising them to eat flower pollen to reverse the effect of the charm. Wise, clever, and loyal, the fox saves his animal brethren and dooms man to track and hunt animals for himself. In retaliation, ceremonial dancers wear fox skins to show that their wisdom equals or betters that of the fox (Tyler, *Pueblo Animals*, 159).

Rabbit

For a small, humble animal, rabbits receive interesting treatment among the Southwestern tribes. Since they reproduce year-round (not seasonally like other game), they are always both an available and an abundant food source. Both cottontails (born hairless and blind) and jack rabbits or hares (born with their eyes open and furred) thrive in most climates year-round.

Rabbits are such easy prey that the Pueblos once made rules for hunting them. At Taos, for example, bows and arrows were weapons of choice, while other Pueblos favored the traditional throwing stick. Hopi and Zuñi hunters used the curved versions, while hunters from Acoma, the Rio Grande Pueblos, Tewa, and Jemez prefered the straight ones called *wobaits*.

Among the Hopi, rabbits are closely associated with deer because they take the same kind of evasive actions when hunted. As they tire, both tend to double back, heading off at right angles to the hunter and then stopping to hide. Because of this similarity rabbits received ritual treatment at Hopi, just like deer. In fact, they are probably the smallest prey animal to be so honored (Tyler, *Pueblo Animals*, 152-3).

Rabbits' great strength is fertility, a quality which links them with the Sun, another fertility symbol. For this reason, they are not hunted during the course of the winter solstice ceremonies. The rabbit plays the role of trickster among the traditions of Native American tribes of the Midwest and the Great Lakes region, although that quality is not emphasized in Southwestern legends.

Prairie Dog

Among the Keres of Santo Domingo Pueblo, the prairie dog figure may be used to invoke the rain gods. Ever alert, the prairie dog exhibits an instinct for gathering, storing, and preserving those things essential to life. Although those qualities are valued, the animal rarely receives ritual treatment as a fetish.

Raccoon, Squirrel, and Others

Many other creatures are carved in response to market demands, special commissions, or simply to challenge the ingenuity of the artist. However, as appealing or skillfully wrought as they may be, they have little or no use within prescribed Southwestern Native American religious and cultural symbolism. Along with common animals indigenous to the North American continent, rare or exotic animals (lions and tigers, for example) are often modeled from pictures in books.

You will encounter lists, supplied by reputable dealers, which assign meanings and values to an array of other animals. For example, the raccoon may be said to represent curiosity, the armadillo, passivity, and the skunk "the ability to understand warnings." On one such list I received, the squirrel was said to exemplify "trust." A little further down the street, another friendly retailer handed me a list which linked the squirrel with "saving" and "thriftiness." You get the picture. These lists usually associate the animal with one of its most readily observed behaviors. Fun as they are, these lists do not necessarily represent "animal spirits" historically grounded in the religion and culture of the Southwestern tribes.

Large mountain lion, 2.5" x 5". Zuñi fetish from the 1940s. (*Courtesy of Dewey Galleries, Ltd., Santa Fe, New Mexico.*)

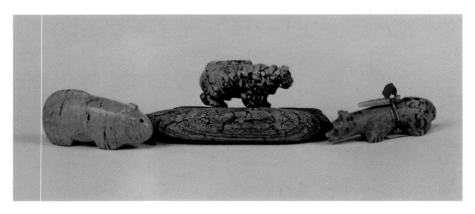

Three turquoise mountain lions, each 2". Left: traditional style with coral eyes. By Sheche family (Zuñi), $100-110. Middle: turquoise heavy with matrix, carver unknown, but probably Zuñi, $75-85. Right: detailed style with coral inlay eyes and shell, arrowhead, and coral bundle. Gasper family (Zuñi). $50-65. (*Courtesy of Tumbleweed Trading, Manayunk, Pennsylvania.*)

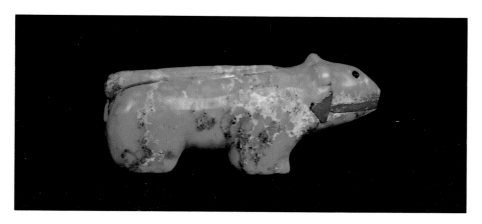

Mountain lion, 0.75", Turquoise with thick coral heartline and jet eyes. Artist unknown. $30-50. (*Courtesy of Turquoise Lady, Albuquerque, New Mexico.*)

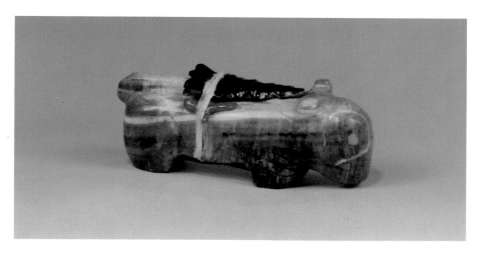

Picasso marble mountain lion, 3". Jet arrowhead and coral bundle. Turquoise eyes. Work of Aaron/Lorandina Sheche. (*Courtesy of Tumbleweed Trading, Manayunk, Pennsylvania.*) $45-65.

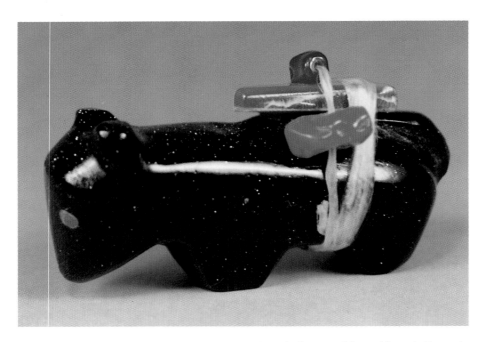

Mountain lion, 1.5". Traditional style with unusual synthetic stone (blue goldstone). Turquoise inlay eyes and turquoise, coral, and shell point bundle. By Carmelia Snow (Zuñi). $45-55. (*Courtesy of private collection.*)

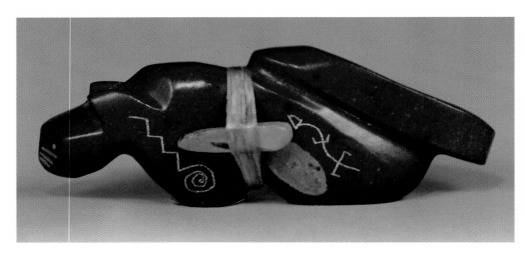

Mountain lion, 6". Carved of pipestone with turquoise eyes and nugget bundle. Petroglyphs on side. Recognizable style of Herbert Halate (Zuñi). $75-85. (*Courtesy of Tumbleweed Trading, Manayunk, Pennsylvania.*)

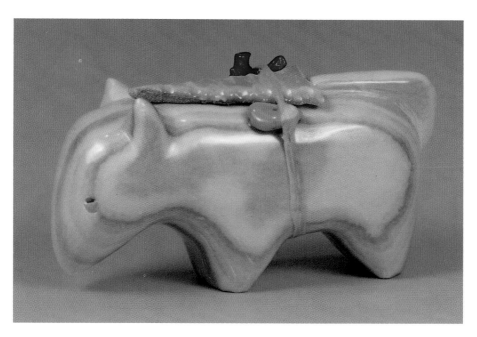

Mountain lion, 3". Carved of beautifully patterned dolomite with turquoise eye and bundle of arrowhead, turquoise, and coral nuggets. By Jessie LeBoeuf of Zuñi. $40-45. (*Courtesy of Ian M. Schwartz, Adobe East Gallery, Summit, New Jersey.*)

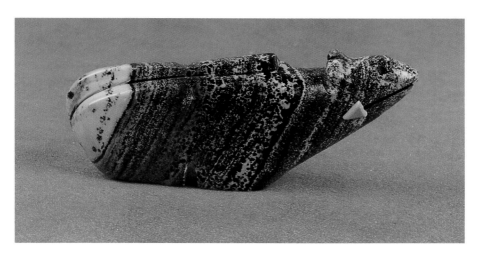

Mountain lion. Carved of banded stone by Navajo artist Livingston. Jet eye and heartline with turquoise point. $50-65. (*Courtesy of Palms Trading Company, Albuquerque, New Mexico.*)

Simple bear form by Sarah Leekya (Zuñi). Turquoise shows heavy matrix. Coral inlay eyes. $80-100. (*Courtesy of a private collector and Adobe East Gallery, Summit, New Jersey.*)

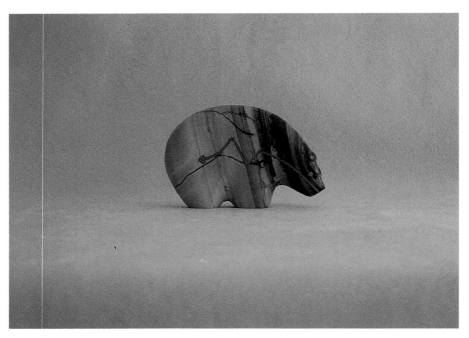

Dolomite bear (4") with exceptional color and pattern. Carved by Zuñi artist Lynn Quam. $150-200. (*Courtesy of Sunshine Studio, Santa Fe, New Mexico/Photo by Challis Thiessen.*)

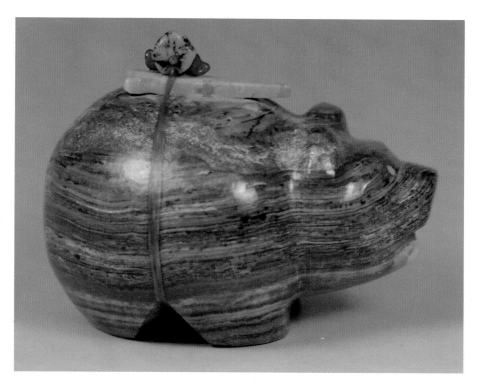

Portly bear of beautifully patterned stone (3"). By Juana Homer (Zuñi). $50-60. (*Courtesy of Ian M. Schwartz, Adobe East Gallery, Summit, New Jersey.*)

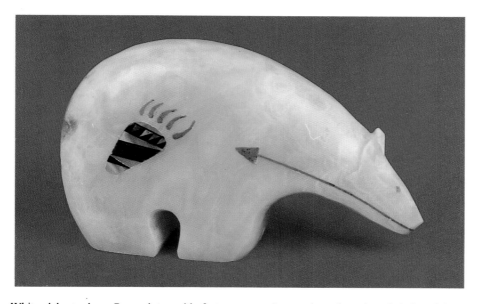

White alabaster bear. Paw print on side features turquoise, mother-of-pearl, and abalone inlay. Turquoise inlay heartline. Unknown artist. $70-80. (*Courtesy of Palms Trading Company, Albuquerque, New Mexico.*)

57

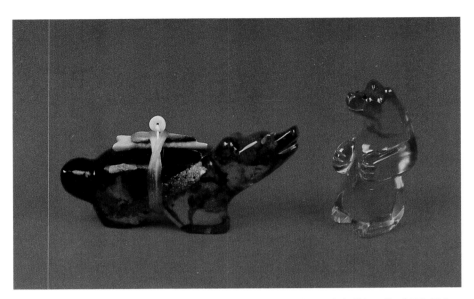

Left: Amber bear (3.25") by Bernard Homer (Zuñi). Turquoise and shell bundle. $200-225. Right: Standing bear (2"). Amber with jet eyes. Probably the work of Loubert Soseeah. $70-85. (*Courtesy of Kiva Indian Trading Post, Santa Fe, New Mexico.*)

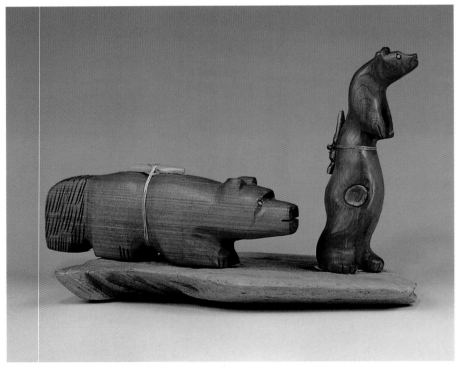

Two bears of cedar. Left: 6", carved by Kyle Mahooty. $50-60. Right: Standing bear, 5.5", contemporary design of Raywee Haloo (Zuñi). $40-50. (*Courtesy of Tumbleweed Trading, Manayunk, Pennsylvania.*)

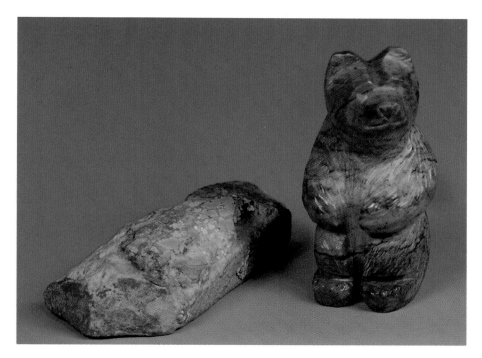

Bear, 3", stands next to a block of raw turquoise. Carved of picasso marble by Vern Nieto. $50-70. (*Courtesy of Fitch's Trading Post, Harrisburg, Pennsylvania.*)

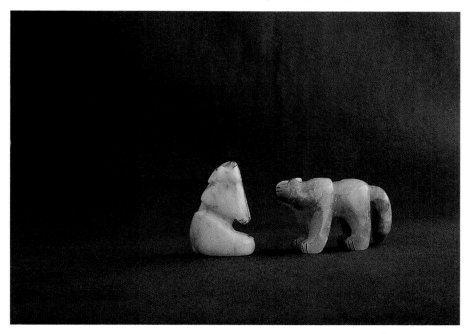

Comical alabaster bears in the distinctive style of Rick Kalestewa (Zuñi). $80-100 each. (*Courtesy of Sunshine Studio, Santa Fe, New Mexico/Photo by Challis Thiessen.*)

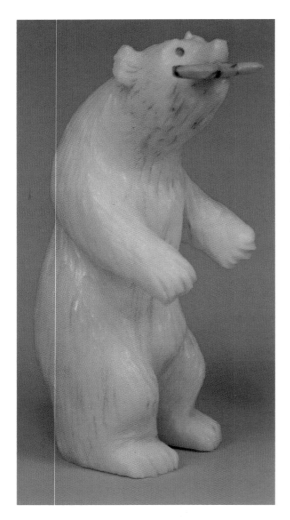

Standing alabaster bear, 5", with turquoise fish. Carver: Frank Tom. Lovely detail in fur. $85-100. (*Courtesy of private collection and Adobe East Gallery, Summit, New Jersey.*)

Stone bear, 3.75" x 7", with carved eagle on back. Turquoise inlay in eyes, heartline, and eagle's necklace. Artist identified as Livingston (Navajo). $230-250. (*Courtesy of Kiva Indian Trading Post, Santa Fe, New Mexico.*)

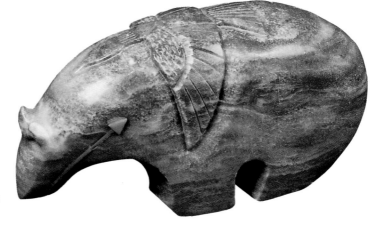

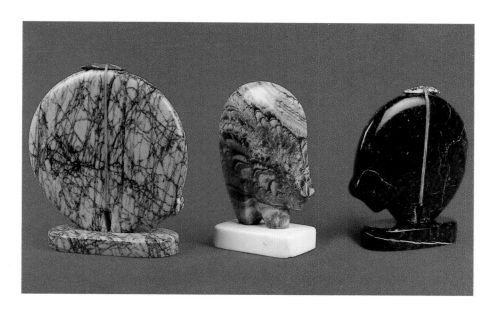

Three bears of beautifully patterned marble. Work of Tom Hays (Plains). $90-100 each. (*Courtesy of Palms Trading Company, Albuquerque, New Mexico.*)

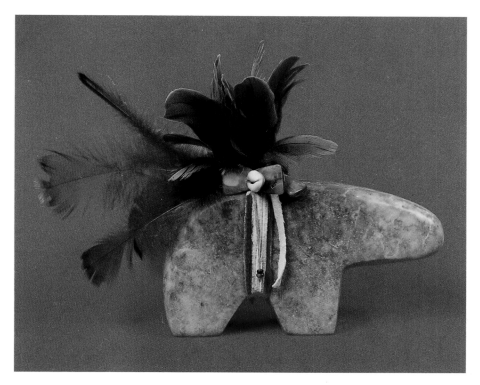

Stone bear, 3.5" x 7", by Mark Swazo Hines (Tesuque). Multi-colored feathers and stones in bundle. $175-200. (*Courtesy of Kiva Indian Trading Post, Santa Fe, New Mexico.*)

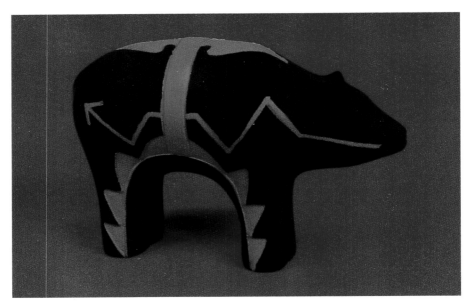

Bear (3.5") of painted clay. Artist: D. L. of Jemez. $20-30. (*Courtesy of Palms Trading Company, Albuquerque, New Mexico.*)

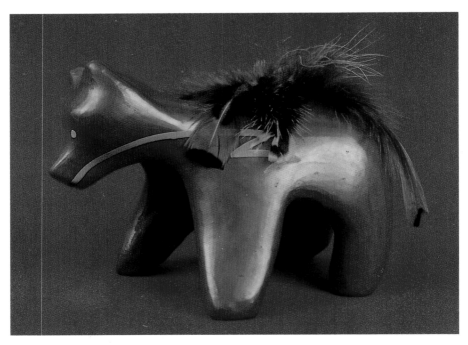

Clay bear by Charles Chinana (Jemez). Painted heartline and feather bundle. $15-20. (*Courtesy of Palms Trading Company, Albuquerque, New Mexico.*)

Jet bear by Dan Sanchez (Isleta). Silver eyes
and heartline. $50-60. (*Courtesy of Palms
Trading Company, Albuquerque, New
Mexico.*)

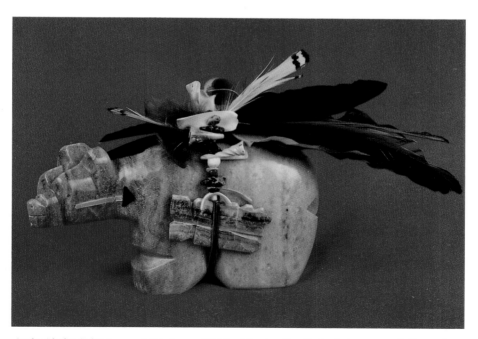

Andy Abeita (Isleta) carved this bear of Utah alabaster. Bundle includes stone, shell, coral,
turquoise, and colorful feathers. $75-100. (*Courtesy of Palms Trading Company, Albuquerque,
New Mexico.*)

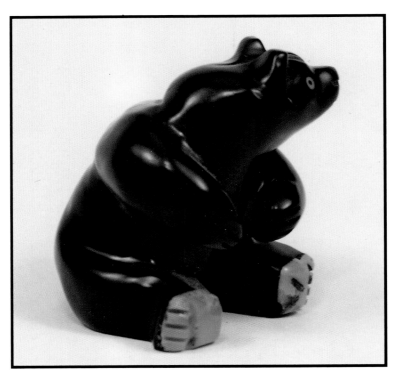

Jet bear with turquoise paws and drilled eyes, 3". By Navajo artist Julia Norton. $55-70. (*Courtesy of The Turquoise Shoppe, Lititz, Pennsylvania.*)

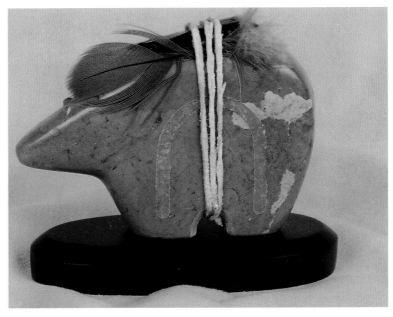

Marble bear on jet base. Crushed turquoise heartline, feathered bundle with jet point. By Samuel Fragua (Jemez). $70-80. (*Courtesy of Turquoise Lady, Albuquerque, New Mexico.*)

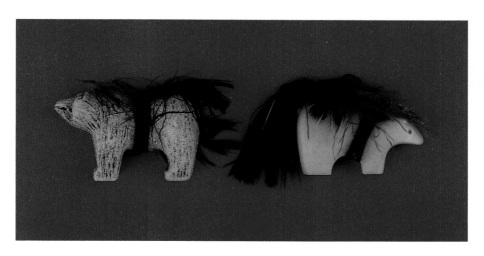

Two bears from the 1940s. Feathered bundles. Unknown artist from Jemez Pueblo. $250-350 each. (*Courtesy of Dewey Galleries, Ltd., Santa Fe, New Mexico.*)

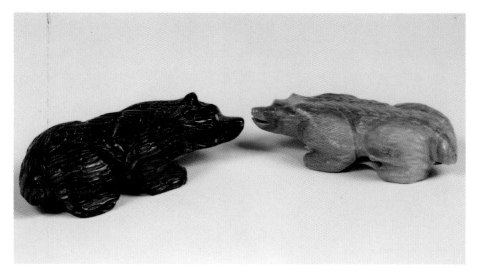

Two badgers by Zuñi artist Clive Hustito. Left: 2.5", jet with turquoise eyes, $80-90. Right: green serpentine, 2", $60-70. (*Courtesy of Fitch's Trading Post, Harrisburg, Pennsylvania.*)

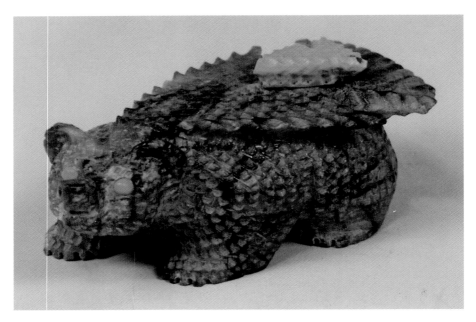

Badger and arrow point, 3", carved from same piece of gray serpentine. By Zuñi artist Alvin Haloo. Turquoise arrow point tops medicine bundle. $60-70. (*Courtesy of Ian M. Schwartz, Adobe East Gallery, Summit, New Jersey.*)

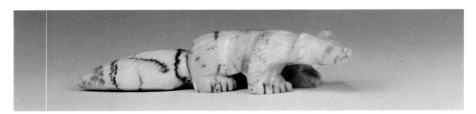

Serpentine badger, 3", with turquoise inlay eyes. By Barney Calavasa (Zuñi). $35-45. (*Courtesy of Turning Point Gallery, Media, Pennsylvania.*)

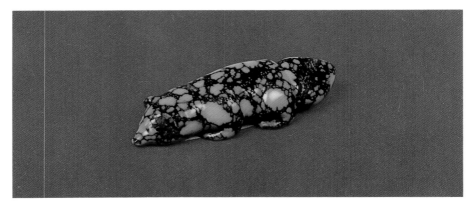

Wonderful matrix on this turquoise badger, 3.75". By Roy Davis (Navajo). $300-325. (*Courtesy of Kiva Indian Trading Post, Santa Fe, New Mexico.*)

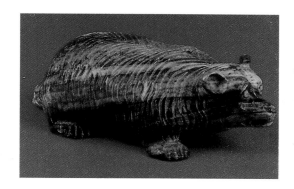

Travertine badger with pierced turquoise eyes. By unknown Navajo artist. $35-45. (*Courtesy of Palms Trading Company, Albuquerque, New Mexico.*)

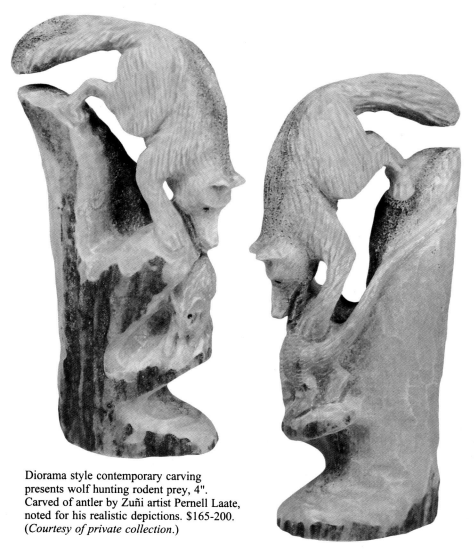

Diorama style contemporary carving presents wolf hunting rodent prey, 4". Carved of antler by Zuñi artist Pernell Laate, noted for his realistic depictions. $165-200. (*Courtesy of private collection.*)

Reverse side of hunting diorama.

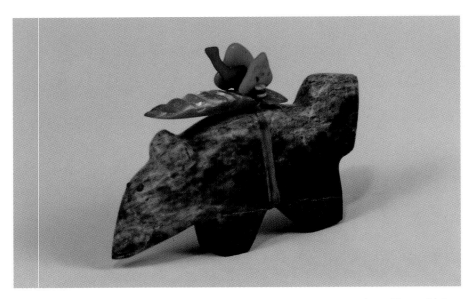

Edna Leki carved this wolf in her own distinctive style, 3". Green serpentine with coral inlay eyes and a bundle of turquoise and coral nuggets and shell arrow point. $45-65. (*Courtesy of Tumbleweed Trading, Manayunk, Pennsylvania.*)

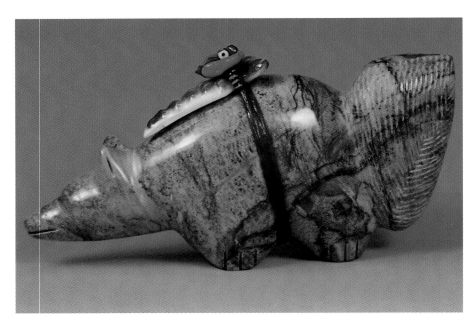

Picasso marble wolf, 6", by Diane Gasper of Zuñi. Turquoise nostrils and eyes highlight her recognizable style. Bundle of arrow point, shell, turquoise, and coral. $180-220. (*Courtesy of Ian M. Schwartz, Adobe East Gallery, Summit, New Jersey.*)

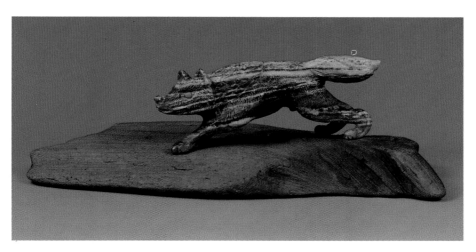

Running wolf, 4.25". Carved from serpentine by Dan Quam (Zuñi). $450-475. (*Courtesy of Ian M. Schwartz, Adobe East Gallery, Summit, New Jersey.*)

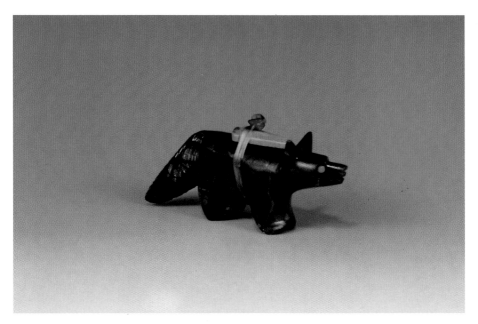

Black marble wolf, 2.5", by Zuñi artist Ronnie Lunasee. Medicine bundle consists of turquoise arrow point bound with nuggets of turquoise and coral. $75-85. (*Courtesy of private collection.*)

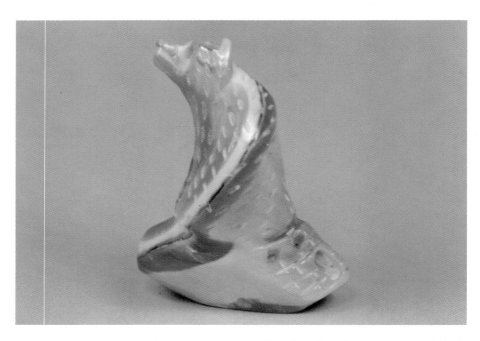

Unusual interpretation of wolf, carved from green snail shell, 1.5". Artist: Lance Deysee. $40-50. (*Courtesy of The Turquoise Shoppe, Lititz, Pennsylvania.*)

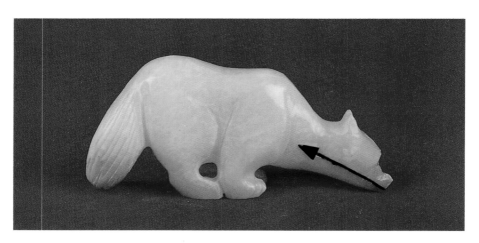

White wolf carved of Colorado alabaster by Livingston (Navajo). $35-45. (*Courtesy of Palms Trading Company, Albuquerque, New Mexico.*)

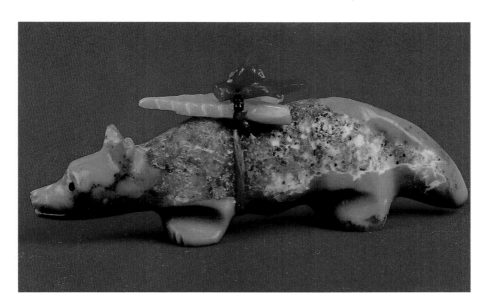

Wolf carving, 1.25", by Davis brothers (Navajo). Turquoise with green matrix, jet eyes, and bundle of shell point, coral, and turquoise nuggets. $65-75. (*Courtesy of Palms Trading Company, Albuquerque, New Mexico.*)

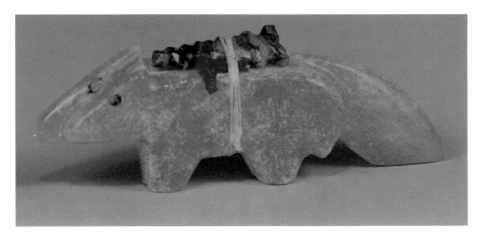

Wolf pair, 4.5". Carved from single piece of alabaster by Sheche family. Male has long tail; female is in front. Turquoise inlay eyes with coral and shell point bundle. $65-75. (*Courtesy of Tumbleweed Trading, Manayunk, Pennsylvania.*)

71

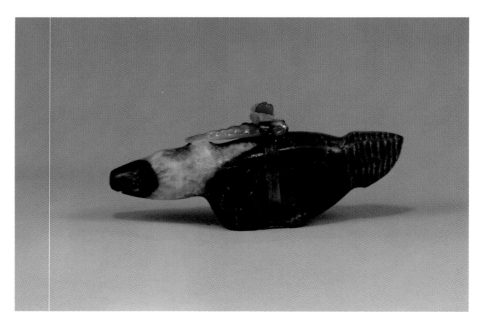

Coyote, 3". Carved of beautiful septarian by Weahkee/Gasper family of Zuñi. Turquoise inlay eyes and medicine bundle of turquoise, coral, and shell point. $40-50. (*Courtesy of Tumbleweed Trading, Manayunk, Pennsylvania.*)

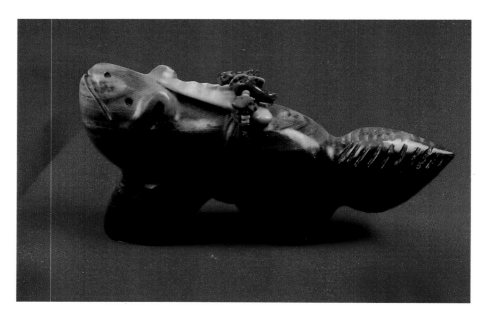

Green serpentine coyote with jet eyes and nostrils. Carved by noted Zuñi artist Anderson Weahkee. Carries full bundle of shell arrow point, heishi, turquoise, and coral bundles. $65-80. (*Courtesy of Andrews Pueblo Pottery and Art Gallery, Albuquerque, New Mexico.*)

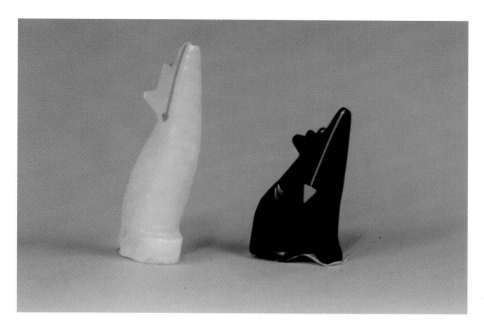

Two coyotes in howling positions. Both with turquoise heartlines. Left: white alabaster, 2.25", by Rhoda Quam (Zuñi), $45-55. Right: jet, 1.75", by Todd Poncho (Zuñi). $40-50. (*Courtesy of Tumbleweed Trading, Manayunk, Pennsylvania.*)

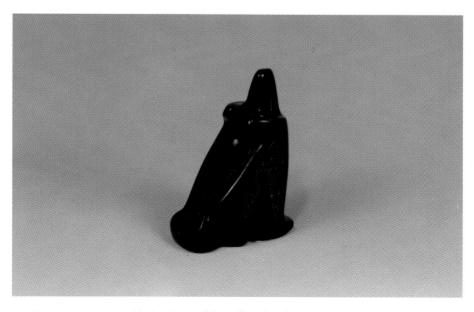

Howling coyote, executed in jet, by Patrick Wallace (Zuñi). Etchings on back and sides. Turquoise inlay on coyote's eyes and insect's head. $50-60. (*Courtesy of Tumbleweed Trading, Manayunk, Pennsylvania.*)

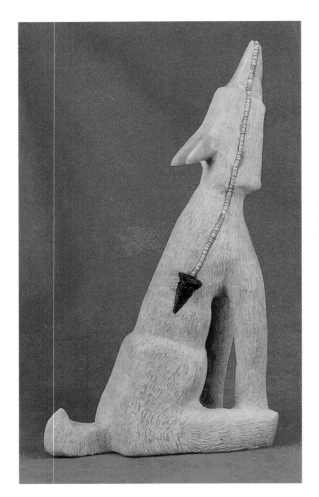

Contemporary "howling" coyote. Carved in alabaster by Navajo artist Glen Jones. Heartline looks like shell. $50-65. (*Courtesy of Palms Trading Company, Albuquerque, New Mexico.*)

Zuñi artist Jessie LeBoeuf carved this serpentine wildcat, 3.5". Bundle includes turquoise and shell. Turquoise inlay eyes. $50-70. (*Courtesy of Tumbleweed Trading, Manayunk, Pennsylvania.*)

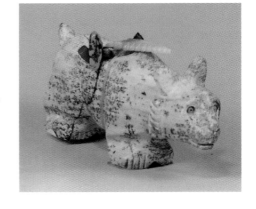

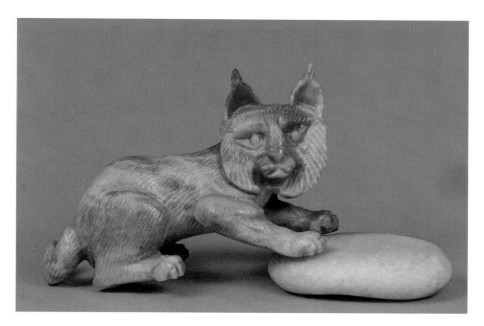

Picasso marble wildcat, 2.5". Carved by Dan Quam of Zuñi. Realistic style. Turquoise inlay eyes. $375-425. (*Courtesy of Ian M. Schwartz, Adobe East Gallery, Summit, New Jersey.*)

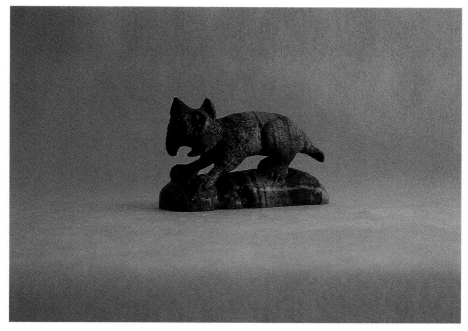

Serpentine wildcat, 4.5". Stands on base of same material. Carved by Zuñi artist Michael Coble. $125-175. (*Courtesy of Sunshine Studio, Santa Fe, New Mexico. Photo credit: Challis Thiessen.*)

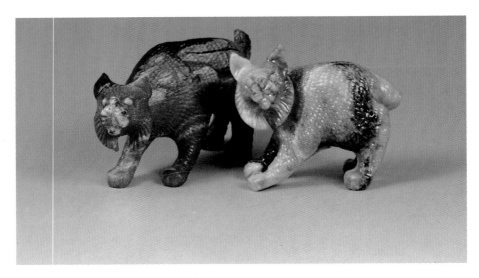

Two wildcats in the realistic style of Wilford Cheama (Zuñi). Left: 3", picasso marble, $195-225. Right: 2", serpentine, $150-175. (*Courtesy of Ian M. Schwartz, Adobe East Gallery, Summit, New Jersey.*)

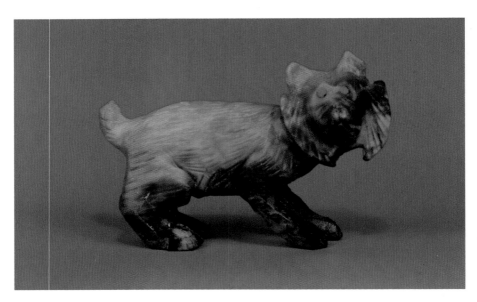

Nelson Yatsattie (Zuñi) carved this picasso marble wildcat, 3". $65-75. (*Courtesy of Turning Point Gallery, Media, Pennsylvania.*)

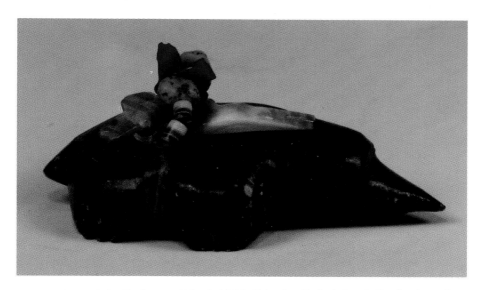

Black marble mole by Zuñi carver Edna Leki. Medicine bundle includes shell point, turquoise, coral, and shell beads. Part of directional set. Mole: $40-50. (*Courtesy of private collector and Adobe East Gallery, Summit, New Jersey*.)

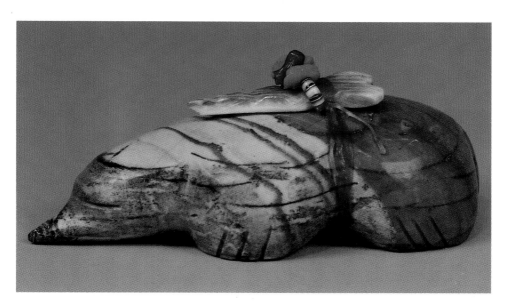

Leland Boone of Zuñi carved this mole, 4", of Zuni Stone. Full bundle of shell point, turquoise, coral, and heishe beads. $80-90. (*Courtesy of Ian M. Schwartz, Adobe East Gallery, Summit, New Jersey*.)

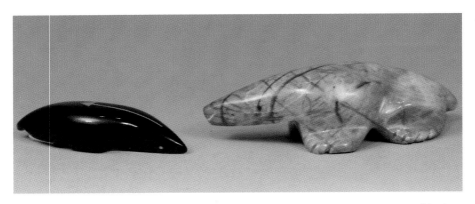

Two mole figures by Zuñi artists. Left: modern-style jet mole, 1.5", by Abby Quam, $35-45. Right: picasso marble mole, 3", by Fred Weekoty, $80-95. (*Courtesy of Ian M. Schwartz, Adobe East Gallery, Summit, New Jersey.*)

Modern-style mole, 1.75". Carved of malachite with turquoise eye by Melissa Quam (Zuñi). $30-40. (*Courtesy of The Turquoise Shoppe, Lititz, Pennsylvania.*)

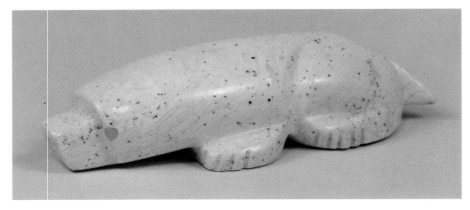

Mole, 2.5". Carved of spotted serpentine by Fred Weekoty (Zuñi). $20-30. (*Courtesy of The Turquoise Shoppe, Lititz, Pennsylvania.*)

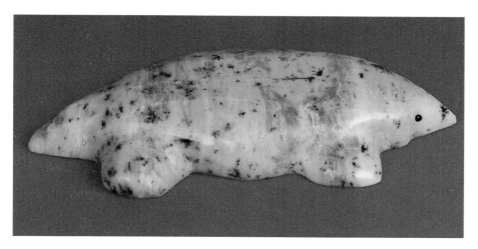

Flat mole of spotted serpentine. Legs stick out to the side. Artist unknown. $25-35. (*Courtesy of Turquoise Lady, Albuquerque, New Mexico.*)

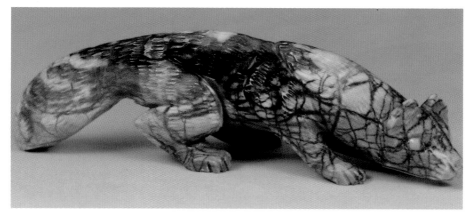

Picasso marble fox. Carved by Dan Quam (Zuñi), noted for his realistic style. $150-200. (*Courtesy of Sunshine Studio, Santa Fe, New Mexico/Photo by Challis Thiessen.*)

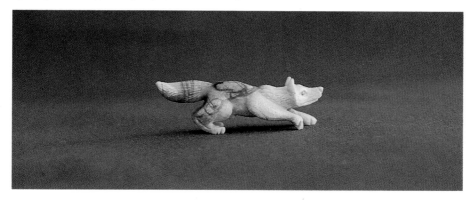

Fox, 5.25". Picasso marble with turquoise inlay eyes. By Lance Cheama (Zuñi). $295-325. (*Courtesy of Ian M. Schwartz, Adobe East Gallery, Summit, New Jersey.*)

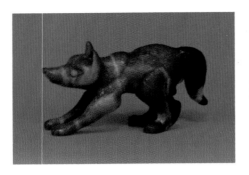

Fox, 2", by Dan Quam. Picasso marble with turquoise inlay eyes. $180-250. (*Courtesy of Turning Point Gallery, Media, Pennsylvania.*)

Fox, 3.5". Spotted serpentine. By unknown Navajo artist. $25-35. (*Courtesy of Palms Trading Company, Albuquerque, New Mexico.*)

Jack rabbit, 1.75". Carved of picasso marble by Celester Laate (Zuñi). $35-45. (*Courtesy of Turning Point Gallery, Media, Pennsylvania.*)

Prairie Dog, 2". Carved of serpentine by Tracey Zunie (Zuñi). $65-75. (*Courtesy of Turning Point Gallery, Media, Pennsylvania.*)

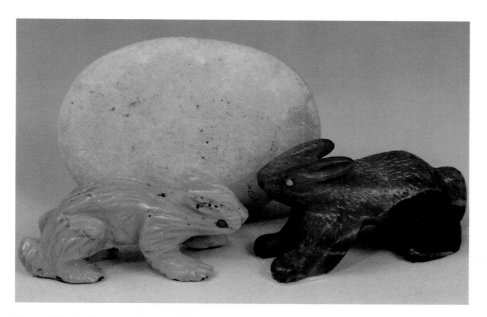

Two rabbits. Left: turquoise, 1", with coral inlay eyes. Artist: Chris Cellicion of Zuñi. $40-50. Right: picasso marble, 2", unknown Zuñi artist. $35-45. (*Courtesy of Ian M. Schwartz, Adobe East Gallery, Summit, New Jersey.*)

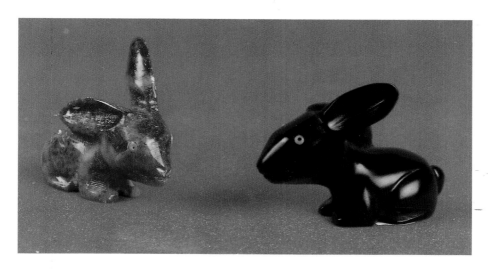

Two rabbits (1" each) by the same Navajo artist. Left is serpentine; right, jet. Both have drilled turquoise eyes. $15-25. (*Courtesy of Palms Trading Company, Albuquerque, New Mexico.*)

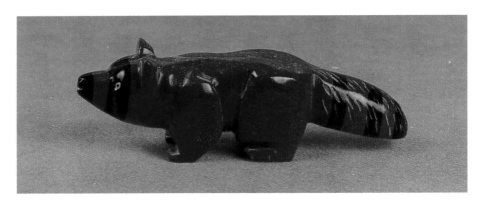

Contemporary style raccoon of pipestone and jet inlay. By Navajo artist Louise Singer. $30-35. (*Courtesy of Palms Trading Company, Albuquerque, New Mexico.*)

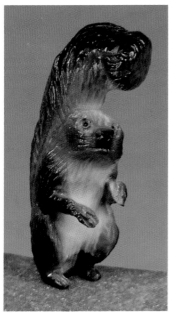

Picasso marble squirrel, 1.25", in realistic style by Zuñi artist Estaban Najera. $105-125. (*Courtesy of private collection.*)

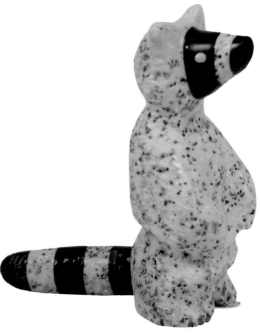

Raccoon, 2". Carved of spotted serpentine with jet inlay by Barney Calavasa (Zuñi). $35-45. (*Courtesy of The Turquoise Shoppe, Lititz, Pennsylvania.*)

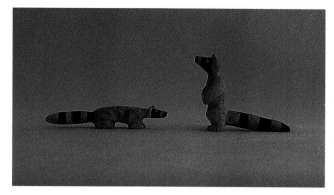

Two raccoons by Barney Calavasa of Zuñi. Both are serpentine with jet inlay. $30-45 each. (*Courtesy of Sunshine Studio, Santa Fe, New Mexico/Photo by Challis Thiessen.*)

Squirrel, 2", by Arvella Cheama (Zuñi). $150-200. (*Courtesy of Turning Point Gallery, Media, Pennsylvania.*)

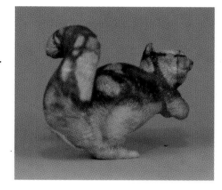

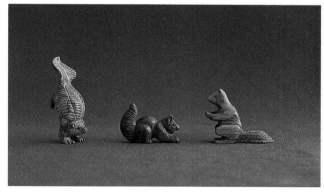

Three small squirrels, three different materials. Left to right: serpentine, carved by Bernie Laselute (Zuñi), $40-60; turquoise, unknown carver, $40-60; cedar, unknown carver, $25-35. (*Courtesy of Sunshine Studio, Santa Fe, New Mexico/Photo by Challis Thiessen.*)

Turquoise beaver by Evalena Boone. Highly polished. Shell, heishe, and turquoise medicine bundle. $35-45. (*Courtesy of Kiva Indian Trading Post, Santa Fe, New Mexico.*)

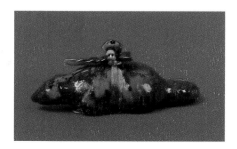

83

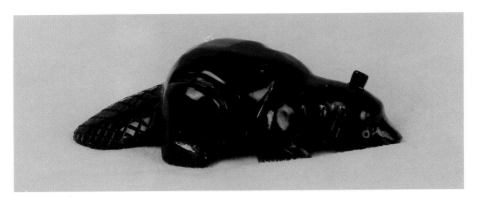

Black jet beaver with drilled eye. Probably the work of Julia Norton (Navajo). $30-35. (*Courtesy of Kiva Indian Trading Post, Santa Fe, New Mexico.*)

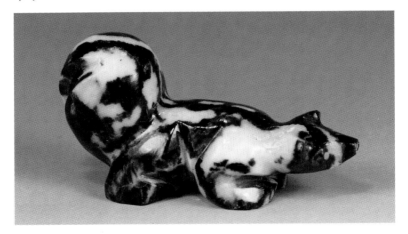

Zebra marble skunk with turquoise inlay eyes, 2". By Garrick Acque of Zuñi. $25-35. (*Courtesy of Turning Point Gallery, Media, Pennsylvania.*)

Skunk, 2.5", of jet with alabaster inlay stripe. Work of Julia Norton (Navajo). $35-45. (*Courtesy of The Turquoise Shoppe, Lititz, Pennsylvania.*)

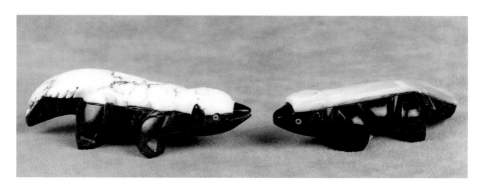

Skunks, 2" and 1.5" respectively, jet with shell inlay stripes. Both with drilled turquoise eyes. Fashioned by Louise Singer (Navajo). $25-35 each. (*Courtesy of Palms Trading Company, Albuquerque, New Mexico.*)

Domestic cat, 1.5". Carved from dolomite by unknown, probably Zuñi, carver. $60-70. (*Courtesy of Tumbleweed Trading, Manayunk, Pennsylvania.*)

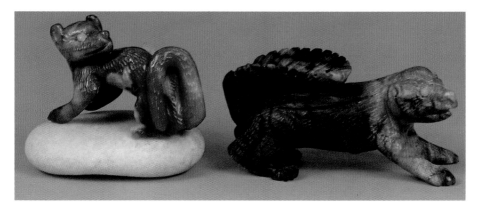

Two carvings by Dan Quam (Zuñi). Both carved from picasso marble with turquoise inlay eyes. Weasel (left): 1.5", $200-225; Skunk (right): 2", $300-325. (*Courtesy of Ian M. Schwartz, Adobe East Gallery, Summit, New Jersey.*)

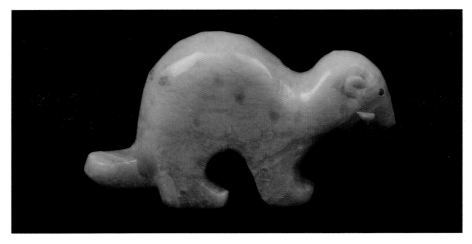

White stone weasel, turquoise eyes and heartline. Unknown Zuñi artist. $25-30. (*Courtesy of Kiva Indian Trading Post, Santa Fe, New Mexico.*)

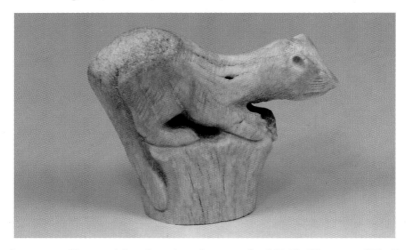

Weasel-on-stump, 3", carved from bone by unknown artist. $45-50. (*Courtesy of The Turquoise Shoppe, Lititz, Pennsylvania.*)

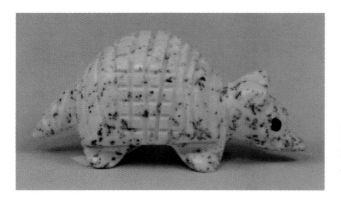

Armadillo, 1.75". Carved of spotted serpentine by unknown artist. Jet eyes. $30-35. (*Courtesy of The Turquoise Shoppe, Lititz, Pennsylvania.*)

Chapter 7

WINGED BEINGS

Even though some birds, such as the eagle and falcon, represent hunting powers, as a group they are primarily associated with clouds and rain. This fact probably comes as no surprise. After all, they are capable of moving between the planes of earth and sky, which is the basis for this connection. Rain mediates between the earth and sky, as do birds, who carry to the heavens prayers for rain and blessings. Birds, too, have assigned roles as guardian spirits in the directional hierarchy, although their identifications are not as rigid as those of animals. For example, although the oriole most frequently mediates between humans and the yellow rain spirits of the north, in a pinch, any bird with yellow coloring will do. The groupings may change for each pueblo, as indicated below.

Birds of the Six Directions

Direction/Color	Zuñi	Hopi
North/Yellow	Yellow-breasted Chat/ Oriole	Flycatchers/ Warblers
West/Blue	Steller's Jay	Bluebird
South/Red	Macaw	Parrot
East/White	Rufous-sided Towhee	Magpie
Zenith/All colors	Purple Martin	Hepatic Tanager
Nadir/Black	Pointed Bunting/ Rough-winged Swallow	Blackbird

(Compiled from D. Tedlock, 499, and Tyler, 9.)

Thanks to the work of Barton Wright on Native American symbolism we know not to expect the thunderbird among the Southwestern bird groupings. While it does have a place of symbolic importance among Plains Indians, it entered the symbolism of the Southwest through industrial die-cuts. They were supplied to Indian artists by entrepreneurs who thought the thunderbird a representative design for all Indians. Thus it appears on Southwestern jewelry, pottery, weavings, even fetish necklaces. Less recognizable outside the pueblos are the bird symbols indigenous to them: the Knife-wing god of the Zuñi and the Kwatoki vulture of the Hopi.

Even the feathers of birds carry great spiritual impact. Attached to fetishes or prayer sticks and accompanied by carved faces and paint, they "stand in" for lives ritually sacrificed to the spirits. Tyler identifies seventy-two species of birds whose wing, tail, and breast feathers find ritual use on prayer sticks (*Pueblo Birds,* 5). Macaw, blue jay, turkey, eagle, flicker, or magpie feathers may be used to decorate the important *mili,* the ear-of-corn fetish presented to each new member initiated into a religious society. It represents the soul of life-giving-power of the creator. The initiate keeps this fetish for the span of his life, breathing on or inhaling from it to acquire strength. After the owner's death, the feathers are removed and added to prayer sticks, the corn kernels are planted, and the remains are buried along with the body.

The intensely sacred nature of their use explains why many Zuñi choose not to attach feathers to fetishes carved for the public market. Indeed, among the members of the Santa Domingo Pueblo, taboos forbid carving birds at all. For that reason, members of this pueblo specialize in heishi or beads often added to fetish necklaces. Those members who do carve birds generally try to remain anonymous (Parks, 10).

Eagle

Like several of the paw-footed creatures, the Eagle (called "White Cap") serves as both Guardian Spirit and Hunter God of the many-colored Upper Region or Zenith. Traditionally, carvings needed relatively little detail to distinguish this winged creature from its four-legged fellows. The simple shape with suggestion of head and tail feathers was sufficient. Sometimes a simple incised "X" upon the back was used to suggest crossed wings. Since in ritual use the eagle is often suspended, it may be pierced for stringing. In fact, birds make up the most frequently carved stringing fetishes. As with most of the other animals, modern tools make it possible to carve in much more realistic detail. The eagles of Herbert and Elfina Hustito are lovely examples.

As a hunter, the eagle is linked in a special relation to the jack rabbit and other small game. But it also maintains important connections to healing, rain, and war. The basis for its sovereignty among birds may rest upon its ability to fly high above all others, making it a powerful overseer and intermediary between the sky spirits and humankind. As a healer it can "carry a shaman in flight when his spirit leaves his body to search for the cause of a patient's illness" (McManis, 17) or as easily scatter among humans the rain or blessings which fall from the sky. As a sky spirit it is closely associated with weather, lightning, and the seasons, appearing as a gentle cloud spirit bringing needed rain or a thundering warrior dispensing lightning, hail, wind, and flood.

Moreover the eagle-shaped Knife-Wing god with his terraced-cloud cap, flint-knife wings, lightning arrows, and rainbow weapon solidifies the relation between war and weather. God of the Warrior Society (the Priesthood of the Bow) along with the Northern and Upper Mountain Lion and the Great White Bear, Knife-Wing teaches the use of flint knives for scalping. Scalping, of course, brings rain.

Since eagle feathers play such an important ceremonial role among the pueblos, special measures must be taken to ensure the needed supply. Eaglets taken from the nest may be raised in cages; their feathers harvested. Other brave souls may participate in the capture of fully-fledged eagles using pits designed for that purpose. In this dangerous procedure, a pit 3 feet square and 6 feet deep is dug near a tree. A bowl of water is placed within, its reflection attracting the eagle. Plants placed around and on top of the pit conceal the hunter inside. A tethered rabbit or other small prey serves as bait; sometimes a tame eagle tethered nearby acts as an additional lure. As the eagle seizes its prey, the catcher beneath reaches through and grabs it, a perilous practice for the fierce eagle will more likely fight than flee (Tyler, *Pueblo Birds*, 56).

Also swift in flight, younger brothers Falcon and Hawk share the same characteristics as the eagle, on a smaller scale. Sometimes they may replace the red eagle in the southern region.

Owl

The relationship of the owl to the night makes it an ambiguous figure. On the one hand, hunting in darkness and shadow, it forges connections with the forces of evil,

harbinger of death. On the other its nighttime vigilance makes it a worthy protector, guarding homes and bringing early warning of approaching danger. Perhaps because of its dual nature, owl fetishes are rarely produced for use by Zuñi tribal members, although they are carved for sale to outsiders. The antler owls carved by the Haloo brothers are especially recognizable.

Crow or Raven

Like the owl, the crow or raven (very like the crow, but larger) suffers an ambiguous reputation in the Southwest. However, crows enjoy closer contact with humans because they too are most active in daylight, and they enjoy the fruits of agriculture, especially corn. In their positive role, the huge, swarming flocks of these birds call to mind the dark clouds of kachinas who bring the rain to nourish the fields and animals. They may also warn of approaching danger. At the same time, it is said that witches may take the form of the crow, spreading disease and ill fortune. Crows and ravens are also associated with war and death, probably because both eat carrion. Because of this unsavory culinary habit, crow feathers do not appear in Zuñi ceremonial offerings, although they may be used on masks.

Tyler has collected a story about the crow in which is embedded a useful lesson about good judgment. The tale is set in the time before the ancestors of today's Pueblo peoples settled in the Southwest. The Sun Spirit puts two eggs into a sacred basket of meal. One egg is a beautiful blue, the other dun or dirty-looking. Granted the privilege of choosing one of the eggs for their own, the people pick the beautiful blue egg. When the egg hatches, the crow emerges, bringing winter and summer and "a competition between thee and me for food." From the dun-colored egg emerged the brilliantly plumed macaw, who flew south carrying with it perpetual summer.

Parrot/Macaw

Although parrots and macaws are not indigenous to the Pueblo area, they were highly prized by the Pueblo peoples. Symbolizing summer, the birds were imported from the south even in prehistoric times. Even loose feathers were imported. The brightly colored plumage—associated with the sun, fire, and the precious turquoise which was often traded for them—made its way into ceremonial regalia. The parrot is also associated with salt, itself a precious commodity. The lakes where it was gathered lay to the south, as did the land of parrots (Tyler, *Pueblo Birds*, 17).

Hummingbird

The hummingbird has quite an exalted history for such a small, fragile creature. Among the old cultures of the Maya, it represented invisibility and indomitable spirit. To the Aztecs it concealed in bird form both Sun and War gods. One old story relates how the bloody "transformative duels between warrior hummingbirds and vampire bats bring rain."

Among the tribes of the Southwest the hummingbird serves a number of ritual uses. Its iridescent colors recall the rainbow, hence its feathers are valued by priests at Zuñi for use in rain invocations. Its speed and stamina make it a logical choice to carry

messages to rain spirits in the clouds. This link to rain is further strengthened by its preference for the tubular blossoms of tobacco plants, the leaves of which are used for cloud-inducing smoke puffed in all directions during rain ceremonies.

So positive is their association with rain and fertility that, according to Tyler, the Zuñi have devised an ingenious method for ensuring a steady supply of feathers. Hummingbird traps are formed by setting loops of horsehair all up and down the bloom of a preferred plant, such as the Rocky Mountain bee plant. The slip knot snares the bird as it searches the blossoms for nectar and pulls tight as it zooms away.

Dove

Like the hummingbird, doves bear a special relation to rain, but for a different reason. Their song is highly valued. In many religious traditions, not just Native American ones, repetitive songs or chants are used in worship. Among the Zuñi, the repetitive call of the dove resembles such a chant or song. It is thought to bring rain. Also, in a dusty day's foraging, doves consume large quantities of dry seeds. At day's end, they head for water to slake their thirst. Following that song or the bird brings thirsty animals and humans a welcome drink.

Duck

In the Southwest ducks are valued more for their feathers than as food. In fact their feathers have ceremonial value just below those of eagle and turkey feathers. The Zuñi believe that spirits summoned for ceremonies take the form of the duck for the return journey home to the clouds or the lakes. For this reason ceremonial dances (like the Shalako procession) end by the river. Also, the observed migratory patterns of ducks are emblematic of the regular, seasonal scattering of seeds, making them bearers of fertility and propagation.

Bats

This unique, winged mammal inhabits both earth and sky. Thus, it shares with other sky spirits the ability to induce rain. It also has a warlike pose. Portrayed in ancient Mayan legend as a fierce, mysterious shape-shifter, it transforms into the powerful jaguar during intense combat. At Zuñi, however, the bat is predominantly respected as a guardian, probably because (like the owl) it roams the at night while others sleep.

Turkey

The humble, down-to-earth nature of the turkey accounts for its value among the Pueblos. Raised by Southwestern cultures for centuries, the turkey is the "only domesticated animal native to North America besides the dog" (Garbarino and Sasso, 58). Since this bird chooses (in theory, at least) to live close to the earth rather than high in the sky, the turkey has obvious value as messenger between gods and humans. Its feathers are so routinely used on prayer sticks that they are referred to as the "clothes"

of the prayer offerings. At Isleta, the turkey feather exceeds even the eagle feather in ceremonial importance. Woven into blankets or adorning prayer sticks, they serve as offerings to the dead who return to earth before becoming clouds. Priests may wear turkey feather capes during important ceremonials.

Roadrunner

Mostly earthbound like the turkey, the roadrunner (also called chaparral cock or ground cuckoo) cannot fly high, but it can glide and run at great speeds. Fierce and audacious enough to challenge and defeat a rattlesnake, this bird is honored by the Knife Order of the Red Ant Society of warriors, thus associating it with war and scalp-taking at Zuñi (Tedlock, 505). With toes arranged two forward and two backward on each foot, its print resembles an "X." This anatomical feat produces a characteristic useful in war. Its enemies cannot tell in which direction it has gone.

Scalp kickers of Zuñi (part of a ceremonial activity) wear roadrunner feathers in the toes of their moccasins during this ritual. This practice links the roadrunner both to scalps and to rain. Scalps bring rain because they are taken from dead people; dead people become cloud people; cloud people bring rain.

Because of its reputed strength and endurance, the spirit of the roadrunner also may be invoked during curing ceremonies, especially those for rheumatic illness and convulsions. Among the Hopi, roadrunners enjoy a less violent reputation. Not associated with scalps, war, or death, they are instead honored as racers whose great speed may be invoked to influence the sun's movement or to hasten the clouds.

Insects

Contemporary carvings also represent insects. Hovering above water, the dragonfly is said to bring rain or the ability to locate sources of water. Like other insects, it receives mythological, if not theological, treatment among the native peoples of the Southwest. The locust and the butterfly—the first rarely seen but often heard, the latter never heard but often seen—together herald the sound and colors of summer.

Butterflies also help the corn grow. Their fluttering movements suggest the motion of clouds, entreating rain. Their colors, again by imaginative relation, recall the many colors of corn. When the yellow butterfly flutters by, yellow corn grows. Along comes the blue butterfly, and the lovely blue corn grows, and so on for the red, white, many colored, and black (dark) varieties.

Yet the butterfly reflects a vastly different, more violent, tradition as well. Surprisingly perhaps, the butterfly is depicted in Mesoamerican art as a great warrior. In this story from San Juan Pueblo, anthropologist Alfonso Ortiz relates how the art of war came to the pueblo. In the story, two boys follow a yellow butterfly west to the Jemez Mountains. There it turns into the Yellow Kachina. The Kachina teaches them the art of war and sends them back to their people with the weapons to wage it.

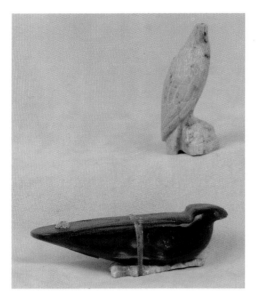

Top: Hawk, finely carved of serpentine. Artist unknown, probably Zuñi. $30-40. Below: bird carved of lapis in traditional style. Red coral eye and turquoise nugget on back. Rests on arrowhead. "X" etched on back represents folded wings. Probably the work of the Sheche family. $35-45. (*Courtesy of Adobe Gallery, Albuquerque, New Mexico.*)

Turquoise eagle poised on rock base, 2.75". Silver talons. Carved by Frank Tom. $110-125. (*Courtesy of Kiva Indian Trading Post, Santa Fe, New Mexico.*)

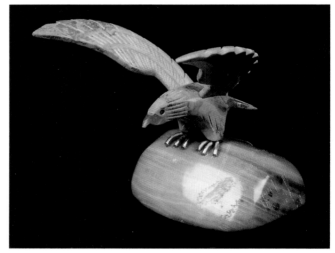

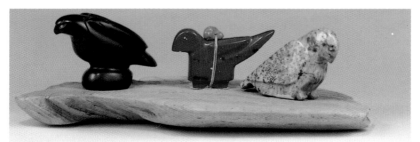

Three birds. Left to right: Jet on jet pedestal with turquoise eyes, $55-65; pipestone with turquoise bundle and tiny turquoise eyes, $50-60. Spotted serpentine eagle carved by Abby Quam and Clayton Panteah (Zuñi), $60-70. (*Courtesy of Tumbleweed Trading, Manayunk, Pennsylvania.*)

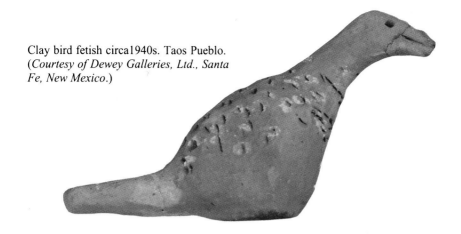

Clay bird fetish circa1940s. Taos Pueblo. (*Courtesy of Dewey Galleries, Ltd., Santa Fe, New Mexico.*)

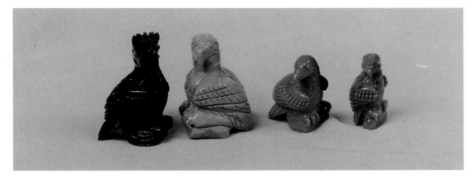

Four eagles from the same artist, probably Zuñi. Left to right: black serpentine, 2.75", $180-200; turquoise eagle, 2.75", $125-150; serpentine hawk, 1.5", $150-160; green serpentine hawk, 1.25", $120-130. (*Courtesy of Kiva Indian Trading Post, Santa Fe, New Mexico.*)

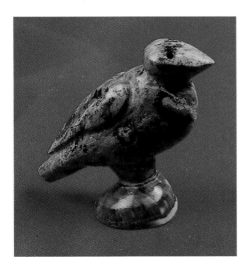

Green serpentine eagle on shell base. Probably the work of the Sheche family of Zuñi. $30-40. (*Courtesy of Andrews Pueblo Pottery and Art Gallery, Albuquerque, New Mexico.*)

Exquisitely detailed eagle, 1.4", carved of antler by Herbert Hustito (Zuñi). $180-200. (*Courtesy of Turning Point Gallery, Media, Pennsylvania.*)

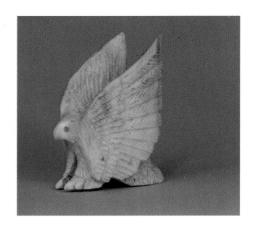

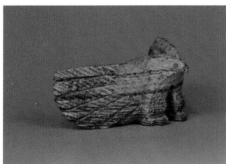

Eagle, 2" wingspan. Carved of serpentine by Elfina Hustito (Zuñi). $75-90. (*Courtesy of Turning Point Gallery, Media, Pennsylvania.*)

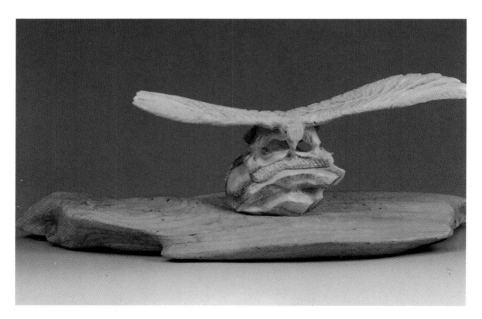

Eagle devours snake, 5" wingspan. Carved of antler by Pernell Laate (Zuñi). $150-165. (*Courtesy of Turning Point Gallery, Media, Pennsylvania.*)

Eagle, 1.5". Antler with very detailed feather etching. By Derrick Kaamasee of Zuñi. Fish in claws (other side). $150-160. (*Courtesy of Turning Point Gallery, Media, Pennsylvania.*)

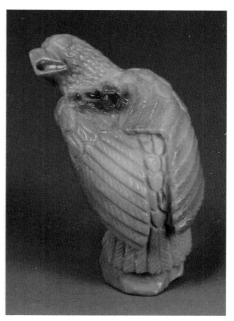

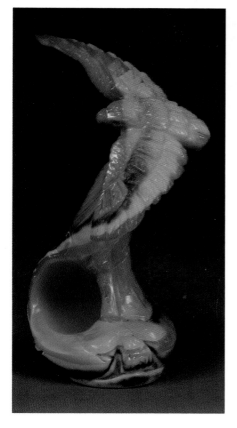

Remarkable coloring on this green-snail-shell eagle in flight, 3". By Chris Tsattie (Zuñi). $105-125. (*Courtesy of Turning Point Gallery, Media, Pennsylvania.*)

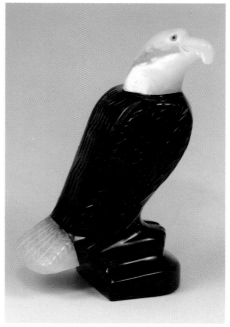

Bald eagle, 2.75". Carved of jet and mother-of-pearl. Drilled turquoise eyes. Artist unknown. $85-95. (*Courtesy of The Turquoise Shoppe, Lititz, Pennsylvania.*)

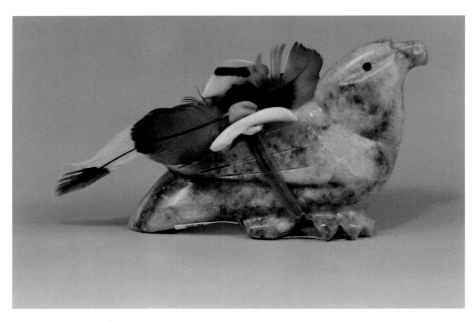

Marbled alabaster eagle, 5.5". By Andy Abeita of Isleta Pueblo. Extraordinarily colorful bundle of feathers, shell, and turquoise. $95-105. (*Courtesy of Tumbleweed Trading, Manayunk, Pennsylvania.*)

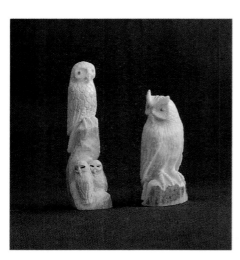

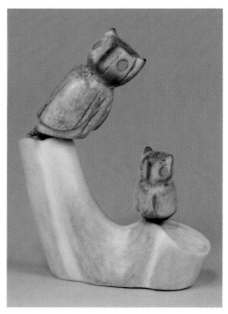

Left: Owl family, 3". Antler. $50-70. Right: Great horned owl, 2". Antler, $80-90. Both by Derrick Kaamasee (Zuñi). (*Courtesy of Sunshine Studio, Santa Fe, New Mexico/ Photo by Challis Thiessen.*

Two owls of antler. Bone base. 3". By Marvelita Phillips of Zuñi. $50-60. (*Courtesy of Tumbleweed Trading, Manayunk, Pennsylvania.*)

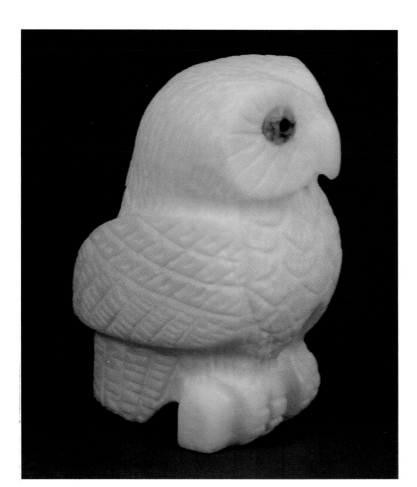

Snowy owl with turquoise and jet inlay eyes, 1.5". By Christine Banteah (Zuñi). $60-70. (*Courtesy of Turning Point Gallery, Media, Pennsylvania.*)

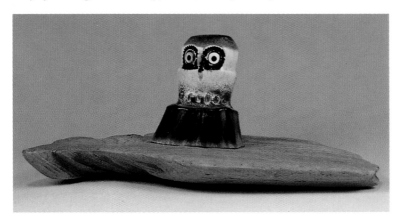

Antler owl, 3", with jet and shell eyes. By Craig Haloo. $45-50. (*Courtesy of Tumbleweed Trading, Manayunk, Pennsylvania.*)

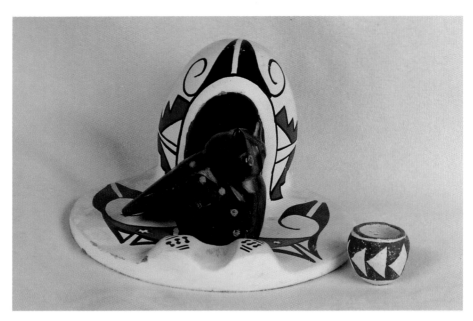

Jet owl with coral eyes and turquoise necklace guards a home of painted pottery. Painted clay bowl for feeding. Artist unidentified. $70-90. (*Courtesy of Turquoise Lady, Albuquerque, New Mexico.*)

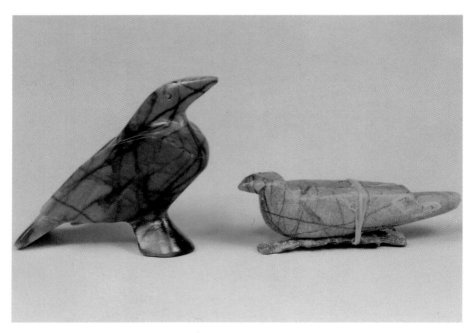

Left: picasso marble raven, 2.5", by Pedia Nastacio. $25-35. Right: traditional-style bird of picasso marble rests on shell point bundle. Etched "X" on back represents crossed wings. Artist: probably Sheche family (Zuñi). $25-35. (*Courtesy of The Turquoise Shoppe, Lititz, Pennsylvania.*)

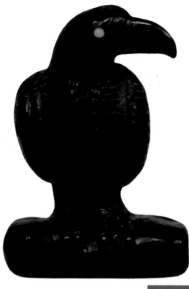

Jet Raven, 4". Carved by B. C. of Zuñi. $150-175. (*Courtesy of Turning Point Gallery, Media, Pennsylvania.*)

Fossil-ivory dove, 1", with turquoise inlay eyes. By Elfina Hustito of Zuñi. Doves are often given as gifts to young girls. $40-45. (*Courtesy of Fitch's Trading Post, Harrisburg, Pennsylvania.*)

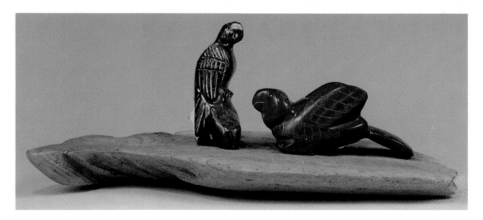

Parrots. Left: green serpentine, 2". Carved by Zuñi artist M. C. $40-45. Right: pipestone, 2.5". Carver unknown. $40-45. (*Courtesy of Tumbleweed Trading, Manayunk, Pennsylvania.*)

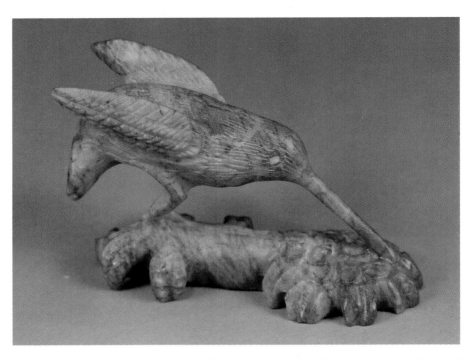

Hummingbird on flower base, 2" long x 1" tall. Picasso marble. Carved by Arvella Cheama of Zuñi. $105-120. (*Courtesy of Turning Point Gallery, Media, Pennsylvania.*)

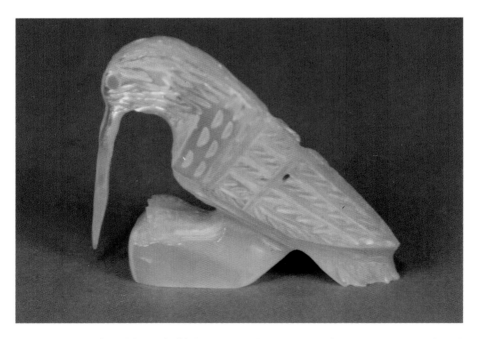

Delicate mother-of-pearl hummingbird, 1". Turquoise eyes. Carved by Celester Laate of Zuñi. $35-45. (*Courtesy of Turning Point Gallery, Media, Pennsylvania.*)

100

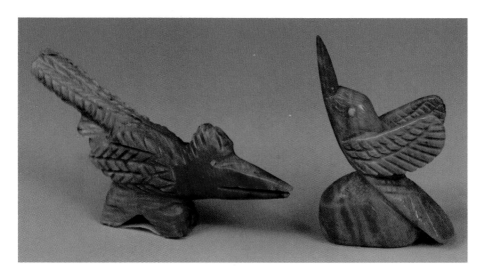

Left: picasso marble road runner, 2". Artist unidentified. $25-35. *Right:* Hummingbird, 1.5. By Vivella Cheama of Zuñi. $75-85. (*Courtesy of Ian M. Schwartz, Adobe East Gallery, Summit, New Jersey.*)

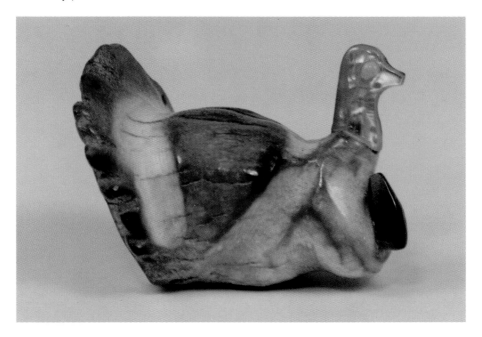

Turkey fashioned from antler. Mother-of-pearl head with turquoise eyes. Artist unknown. $30-35. (*Courtesy of Christine Williams.*)

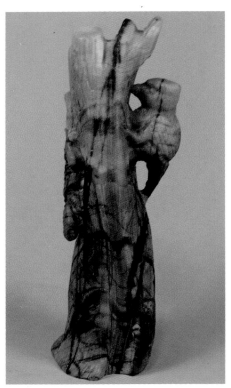

Woodland scene of picasso marble. Woodpecker with turquoise inlay eyes shares tree with lizard on left side, 4.5". Carved by Arvella Cheama of Zuñi. $210-230. (*Courtesy of Ian M. Schwartz, Adobe East Gallery, Summit, New Jersey.*)

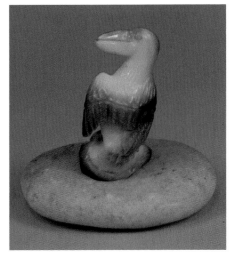

Antler pelican, 1". Carved by Derrick Kaamasee (Zuñi). $80-90. (*Courtesy of private collection.*)

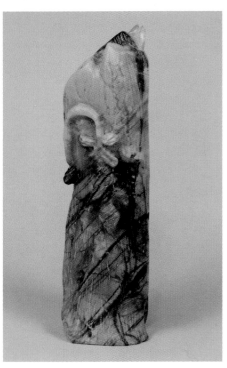

Lizard crawls on side of the tree opposite the woodpecker.

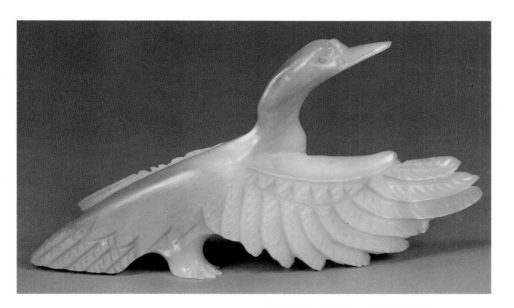

Goose, 3" x 2.5". Carved of mother-of-pearl by Zuñi artist Robert Halusewa. $50-60. (*Courtesy of Turning Point Gallery, Media, Pennsylvania.*)

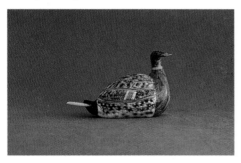

Duck, 4.25", by Sullivan Shebola uses cowrie shell for a surprisingly realistic effect. $100-150. (*Courtesy of Sunshine Studio, Santa Fe, New Mexico/Photo by Challis Thiessen.*)

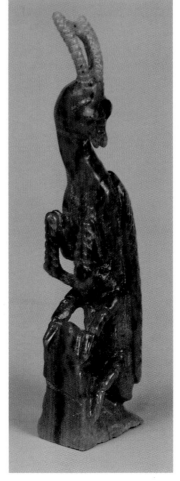

Praying Mantis, 4". Carved in incredible detail from green serpentine. Artist: Derrick Kaamasee (Zuñi). $90-100. (*Courtesy of Turning Point Gallery, Media, Pennsylvania.*)

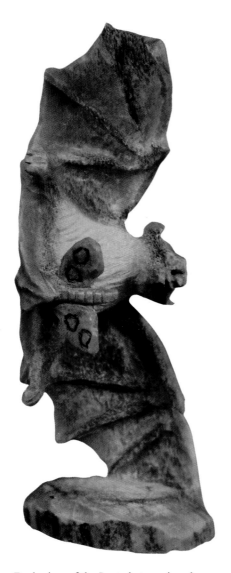

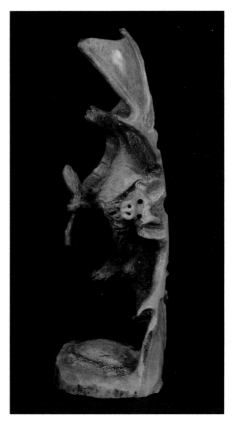

Antler bat, 3.5". Carved in exquisite detail by Max Laate (Zuñi). Holds moth in claws. $120-130. (*Courtesy of Turning Point Gallery, Media, Pennsylvania.*)

Back view of the Laate bat carving shows detail of captured moth.

Elfina Hustito of Zuñi carved this small bat, 2", of jet. $60-70. (*Courtesy of Tumbleweed Trading, Manayunk, Pennsylvania.*)

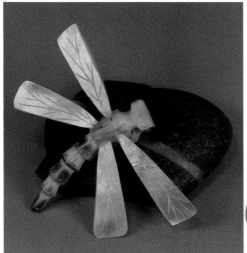

Derrick Kaamasee created this unusual dragonfly from antler, 4" wingspan, 3" body. Wings are mother-of-pearl. Turquoise inlay eyes. $75-85. (*Courtesy of Turning Point Gallery, Media, Pennsylvania.*)

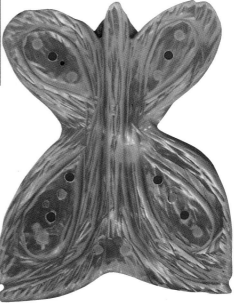

Butterfly, 2", carved from mother-of-pearl. Artist: Barry Yamutewa, Zuñi. Inlay of coral and turquoise adds color. $50-60. (*Courtesy of Ian M. Schwartz, Adobe East Gallery, Summit, New Jersey.*)

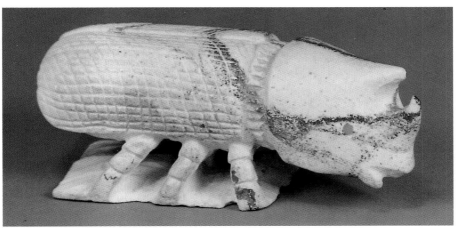

Rhinoceros beetle, 2.5". An unusual choice of subject, well executed by Derrick Kaamasee (Zuñi) in unidentified stone. $60-70. (*Courtesy of Turning Point Gallery, Media, Pennsylvania.*)

105

HORNED AND HOOFED BEINGS

Like their counterparts among the Prey Gods and Winged Beings, many of the horned and hoofed animals are identified with specific directions: North, mule deer; West, mountain sheep; South, antelope; East, white-tailed deer or white antelope. More importantly, the bodies of these horned and hoofed animals, in honor of their sacrifice, receive ritual treatment after the hunt which kills them. With the performance of proper rituals, their spirits travel to Kachina Village at the bottom of the lake near Zuñi where their lives are restored. In this way the Pueblo peoples ensure a plentiful supply of food.

Wild horned creatures, more mysterious than their domesticated counterparts, are considered more powerful, more holy, than cows or goats or sheep. In earlier times fetishes of these creatures were rarely carved because of the difficulty of representing horns and slender, fragile legs. Modern tools now enable carvers like Max Laate to produce stunningly beautiful and realistic likenesses. Carvings also portray domesticated livestock such as cattle, horses, sheep, and goats.

Deer and Elk

Linked in dynamic relation to the Mountain Lion Hunting God, deer, antelope, and elk play powerful roles in the religious life of the Pueblo tribes. Of the three, deer play the most prominent role. Not only does the deer provide food and clothing, but it is allied as well to that element most precious to desert peoples, water. Killing deer brings clouds, spirits of the dead. When Zuñi kachinas die, they are said to become deer. In fact, in the important Shalako ceremony, "deer" dancers are symbolically killed to re-enact the hunting cycle in which deer provide the necessities of life: food, clothing, and water. In his study of Southwestern Indian symbols, Wright acknowledges the emblematic value of the split-hoofed deer print as code for food.

In her long-term study of Zuñi culture, *The Beautiful and the Dangerous*, Barbara Tedlock describes another transformation involving deer. Apparently humans may be reborn as deer up to three times. After their fourth deer-life, they return as stink-bugs. After their death as insects, they return for a final time to the Place of Emergence. Other important qualities related to deer (and sometimes antelope) include speed and fertility. Fertility fetishes carved of deer horn recognize and honor the fact that deer mothers nearly always produce twins, often male and female fawns.

Among the Rio Grande Pueblos, elk also play an important role in rituals of propagation and regeneration. Tyler tells how the small Tewa tribe enacted the Elk Dance Ceremony to restore their diminishing numbers. Since they had no ceremony of their own, they borrowed one from their neighbors at Taos at a cost of ten turquoises, five hard red beads, twelve dance blankets, and twelve deer skins. Tribal elders actually sold some of their land to the Spanish to amass that price. Through the ritual they entreated the elk spirit to ensure the growth and vitality of their people.

Buffalo

Even though buffalo do not range as far south as the current site of the Southwestern Pueblos, the tribes encountered this powerful horned beast along northern trading

and hunting routes. If deer are related to rain, buffalo are allied with more fierce weather patterns: hail, wind, and snow. The buffalo's relation with the winds may stem from the observed behavior of buffalo herds. As we all know from TV westerns, stampeding buffalo herds (cattle, too, for that matter) cannot be stopped. A powerful and dangerous force, the herd represents the power generated by group behavior or concerted force over individual effort. At the same time, the intense dust clouds accompanying the passage of sizable buffalo herds make the wind visible. Ritual burning of a buffalo head is said to relieve the burning winds which sweep the Southwest in the spring.

Among the members of Cochiti Pueblo, buffalo both cure illness and bring snow. Snow not only melts to replenish water in the thirsty Southwest but it also drives game (deer, elk, mountain sheep) down from the difficult reaches of the mountains, providing food for the people below.

Mountain Sheep/Ram

Especially among the Hopi, mountain sheep enjoy a symbolic link with the locust, whose fluting notes forecast the coming of summer. Mountain sheep, like deer, assume roles in rituals of fertility or growth. Dancers execute magnificent leaping movements in imitation of the agility, energy, and fecundity of these creatures.

The figure of the ram may be associated with wild sheep or with the domesticated variety. In either case it is a figure of virility, charged with increasing the size of the herd. Ram and sheep fetishes may also be used as talismans to protect flocks or herds from disease, predators, and accidents. Domestic livestock fetishes are particularly valued among the Navajo, to ensure the growth and protection of their herds. Some images they make themselves, some they purchase from the Zuñi or other neighbors.

Horse

Horses hold a special place among native Southwestern peoples. Brought to the area during the period of Spanish conquest, horses greatly influenced the cultures who learned to use them. Powerful allies, horses made it possible for humans to carry heavy burdens farther and faster than ever before.

The horse has played a special role in the lives of both Navajo and Apache tribes. Acquisition of the horse allowed them to extend their territory, raiding their neighbors more frequently and with greater success than before. Fetishes of these animals—some procured in trade from Zuñi, some carved by Navajo themselves—might be carried to locate strays, to drive herds, to prevent disease, or to provide stamina for long journeys.

So important did horses become that the Navajo felt the need to explain in myth why Spanish invaders acquired them first. In her book *They Sang for Horses*, La Verne Harrell Clark tells how in the oldest times, the Twin Gods asked Father Sun for gifts with which the people might slay the Monsters threatening them. After carefully studying the array of possible weapons, they refused the horses, choosing instead "lightning, sun rays, and rainbow arrows," more effective against Monsters. In the story they wisely selected a gift appropriate for their needs at the time, trusting that Changing Woman would provide the coveted animals later when the time was right.

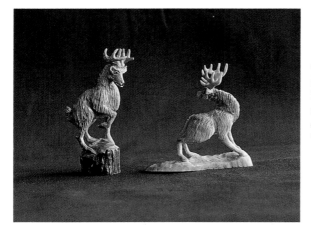

Two deer, carved of antler in realistic detail. Specialty of Pernell Laate (Zuñi). $125-150. (*Courtesy of Sunshine Studio, Santa Fe, New Mexico/Photo by Challis Thiessen.*)

Alabaster ram with turquoise heartline. Beautiful bear-paw shaped inlay design of jet, turquoise, coral, and shell on the side. Artist: probably Chris Yuselew (Zuñi). $100-125. (*Courtesy of Palms Trading Company, Albuquerque, New Mexico.*)

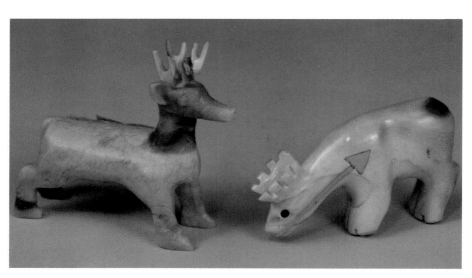

Left: Deer, 1.25", carved of picasso marble by Raybert Kanteena (Zuñi). Turquoise inlay eyes, $75-85. Right: Grazing deer, 1". Fossil ivory, carved by Andres Quandelacy. Jet eyes and turquoise inlay heartline, $90-100. (*Courtesy of Ian M. Schwartz, Adobe East Gallery, Summit, New Jersey.*)

Mountain Goat/Ibex, 3". Carved of antler by Zuñi artist Pernell Laate. Eyes are carved, not inlaid. $135-150. (*Courtesy of Turning Point Gallery, Media, Pennsylvania.*)

Ram, 2.5". Stylishly rendered in pipestone by Gilbert Lonjose (Zuñi). $35-45. (*Courtesy of Ian M. Schwartz, Adobe East Gallery, Summit, New Jersey.*)

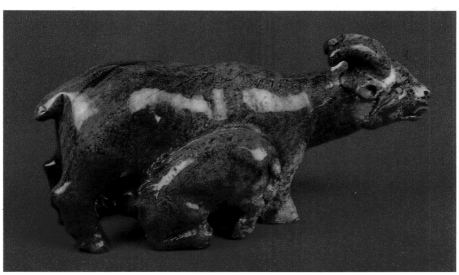

Serpentine nanny goat nursing kid. Highly polished. Unidentified, probably Zuñi, artist. $40-65. (*Courtesy of Palms Trading Company, Albuquerque, New Mexico.*)

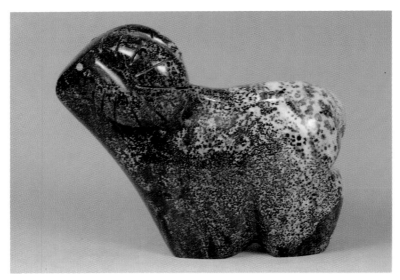

Ram, 3.5" tall x 3.5" wide, carved of beautiful spotted serpentine by Alvin Sheche of Zuñi. $180-200. (*Courtesy of Ian M. Schwartz, Adobe East Gallery, Summit, New Jersey.*)

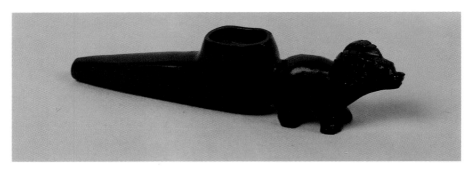

Pipe with attached ram, 6". Carved of pipestone by unknown Zuñi artist. $100-125. (*Courtesy of Kiva Indian Trading Post, Santa Fe, New Mexico.*)

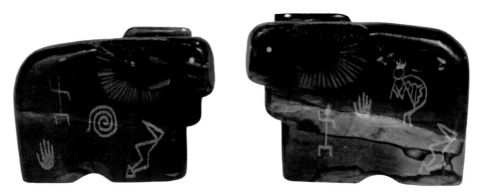

Rams, carved of picasso marble by Zuñi artist Ulysses Mahkee. Distinctive petroglyph etchings on the sides. Turquoise inlay eyes. Left: 2", $50-60. Right: 2.5", $60-70. (*Courtesy of Tumbleweed Trading, Manayunk, Pennsylvania.*)

110

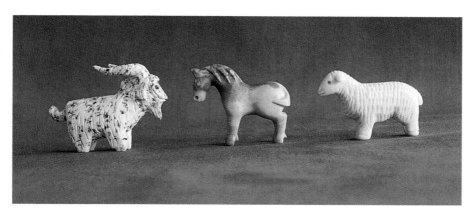

Left: Serpentine goat by Julia Norton (Navajo), $35-45. Center: Picasso marble horse by Karen Zunie (Zuñi), $50-60. Right: Alabaster sheep by unidentified Navajo artist, $30-40. (*Courtesy of Sunshine Studio, Santa Fe, New Mexico/Photo by Challis Thiessen.*)

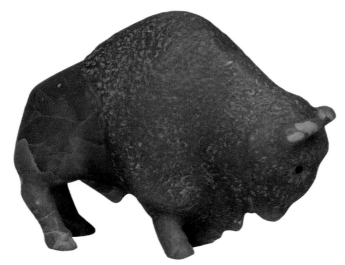

Buffalo, 6", carved of angelite. Jet inlay eyes. By Zuñi artist Herbert Him. $300-350. (*Courtesy of Turning Point Gallery, Media, Pennsylvania.*)

Buffalo with an attitude, 1.5". Superb carving of serpentine by Dan Quam (Zuñi). $400-450. (*Courtesy of Tumbleweed Trading, Manayunk, Pennsylvania.*)

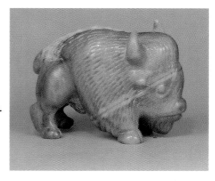

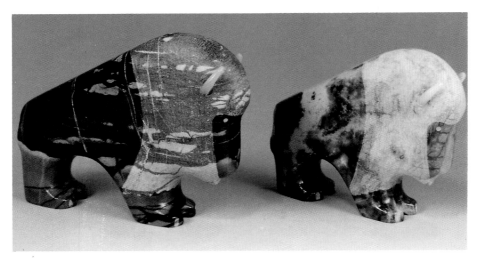

Two buffalo, 2"-2.5", in the distinctive style of Todd Westika (Zuñi). Polished black marble with unpolished manes, turquoise eyes, and mother-of-pearl horns. $75-85. (*Courtesy of Turning Point Gallery, Media, Pennsylvania.*)

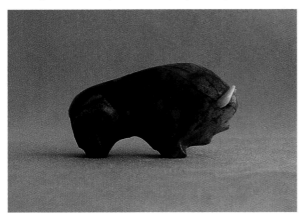

Picasso marble buffalo with mother-of-pearl horns and turquoise inlay eyes. Work of Zuñi artist Lynn Quam. $60-75. (*Courtesy of Sunshine Studio, Santa Fe, New Mexico/Photo by Challis Thiessen.*)

Stone buffalo with eagle carved back, 2.25" x 4.25". Turquoise eyes, horns, and heartline. Eagle's necklace is coral with turquoise pendant. Unpolished mane. Carved by Zuñi artist BL. $80-120. (*Courtesy of Kiva Indian Trading Post, Santa Fe, New Mexico.*)

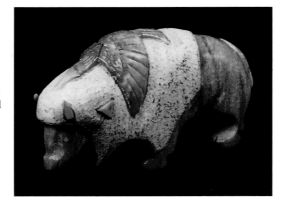

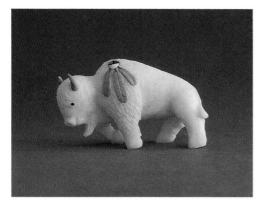

White alabaster buffalo with turquoise feathers on shoulder. Work of Frank Tom. (Navajo) $50-70. (*Courtesy of Sunshine Studio, Santa Fe, New Mexico/Photo by Challis Thiessen.*)

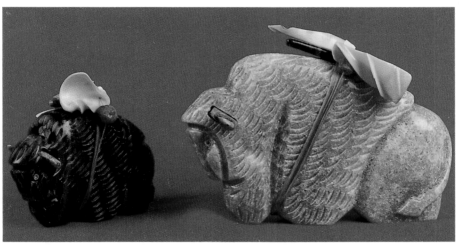

Stone buffaloes carved by Andy Abeita (Isleta). Bundles of stone, shell, and coral. Horns carved and attached separately. Left: 3.5", $70-85. Right: 4.75", $85-100. (*Courtesy of Palms Trading Company, Albuquerque, New Mexico.*)

Turquoise horse with jet inlay eyes, 1". Carved by Carol Martinez of Zuñi. $35-50. (*Courtesy of Turning Point Gallery, Media, Pennsylvania.*)

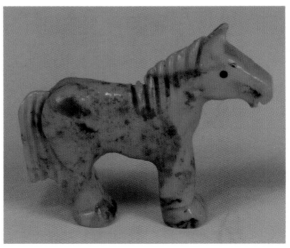

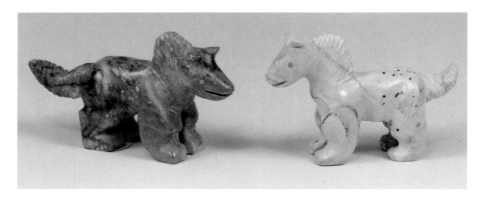

Horses in the very recognizable style of Keith Bobelu (Zuñi). Left: 2.5", picasso marble with turquoise inlay eyes, $35-45. Right: 2.25", serpentine with turquoise eyes, $35-45. (*Courtesy of The Turquoise Shoppe, Lititz, Pennsylvania.*)

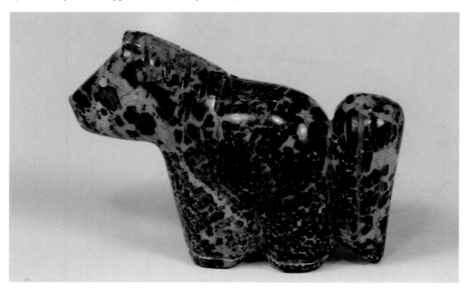

Horse, 2". Carved of moss serpentine by unknown Zuñi artist. $45-60. (*Courtesy of Ian M. Schwartz, Adobe East Gallery, Summit, New Jersey.*)

Polished jet horse, 3", with turquoise arrow point bundle and turquoise eyes. By Herbert Halate (Zuñi). $45-60. (*Courtesy of Tumbleweed Trading, Manayunk, Pennsylvania.*)

114

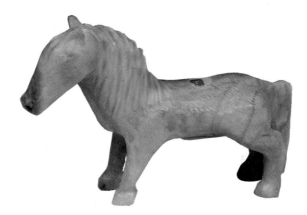

Picasso marble horse, 2", by Raybert Kanteena of Zuñi. On back, inlaid Zuñi sunface of turquoise, coral, and mother-of-pearl. $100-125. (*Courtesy of Ian M. Schwartz, Adobe East Gallery, Summit, New Jersey.*)

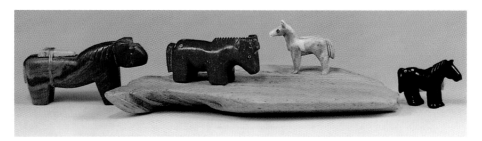

Left to right: travertine horse, 3", by Virginia Toombs of Zuñi, $30-40; pipestone horse, 2", with turquoise dapples on rump, by Julia Norton (Navajo), $45-55; serpentine horse, 1.25", by unknown artist, $45-55; jet horse, 1.5", by Carol Martinez (Zuñi), $60-75. (*Courtesy of Tumbleweed Trading, Manayunk, Pennsylvania.*)

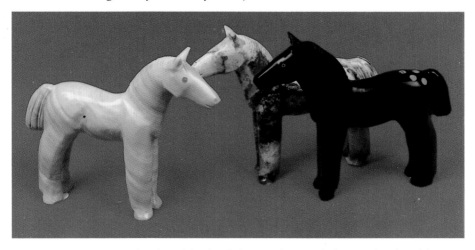

A herd of horses carved of (left to right) banded serpentine, mottled serpentine, jet with turquoise dapples on rump. Artist unknown. $50-70 each. (*Courtesy of Kiva Indian Trading Post, Santa Fe, New Mexico.*)

115

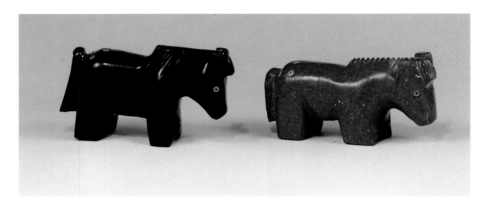

Two Appaloosa ponies by Julia Norton (Navajo). Both are 2" tall, with drilled turquoise eyes and dapples on rump. $40-55 each. (*Courtesy of Tumbleweed Trading, Manayunk, Pennsylvania.*)

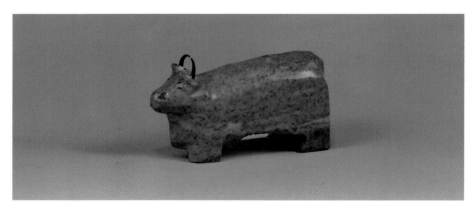

Cow, 3", carved of serpentine by Leonard Halate of Zuñi. Bird claw horns, turquoise inlay eyes, and coral nostrils. $50-75. (*Courtesy of Tumbleweed Trading, Manayunk, Pennsylvania.*)

COLD-BLOODED BEINGS

Snake

Snake fetishes represent the most powerful class of fetishes in Zuñi theology. The oldest ones were carved out of a length of deer horn with tail or face etched on either end. Some versions also wear headdresses and look very fierce. Although the most frequent manifestation now is the rattlesnake, these early images more clearly recall the legendary Plumed Water Serpent, even more powerful in Zuñi cosmology than the Beast Gods.

Snakes resemble lightning in both swiftness and form. Therefore, in the Pueblo system of likeness and relation, by necessity they must be connected. Both manifest power as rain and fertility fetishes. Their sharp fangs resemble the sharp edges of arrow points. Related, they bring consummate power and prowess to hunting. When the skins or body parts of dangerous animals like the mountain lion or bear are needed for ceremonial purposes, the power of the snake is invoked to overpower the spirit of that animal and render its body vulnerable to the human hunter. Invoking snake power involves a complex system of ritual prayers and *teshqui*, sacred conduct that requires fasting, continence, and silence among other observances.

Along with certain healing powers, snake fetishes can unmask witches. Kirk records one case in which a snake-shaped war club fetish was used to subdue a witch. Her informant recalls, "They can beat down on a witch with that thing and the witch cannot hurt them because that snake [is] so strong it protects the War Chiefs." Cushing describes the practice of rubbing a snake's head fetish on the hands, body, and legs of Zuñi boys preparing for battle (reported in Kirk, 48). A powerful medicine helper but also a dangerous elemental force, the lightning power of the snake is called upon sparingly, in times of greatest need.

Frog and Turtle

Frogs represent one of the most popular subjects among fetish carvers of the past and present. Even with primitive tools their rounded shape could be coaxed with relative ease from many natural forms, especially bi-valve shells. For this reason their image adorns some of the earliest jewelry of the prehistoric past. A rain-inducing fetish, frog images may be buried near streams, water holes, or rivers to encourage the continued presence of water. Moreover, anyone who has ever examined a small puddle absolutely teeming with tadpoles will have no trouble at all predicting the connection between frogs and fertility.

Turtles also play an important role in some Native American cosmologies or world views. The belief in "Turtle Island" imaginatively pictures the earth carried slowly along upon the back of a turtle. In Zuñi tradition, however, turtles bring fertility and longevity. Perhaps because the turtle itself enjoys long life, Navajo medicine bags shaped or decorated to resemble turtles ask similar longevity for their owners.

Lizards

Lizards and other reptiles enjoy a decorative life on Zuñi pots and in paintings but hold little or no place in religious practice. One Zuñi tribe member reportedly explained to Kirk the use of the lizard image on a scalp fetish jar this way: "The lizard is hard to get along [with.] Nobody like lizards. When dance comes along, nobody like ghosts. When the scalp on the pole, nobody likes scalps. And nobody likes lizards, that is why that is on." Perhaps lizard or reptile figures once provoked fear and repulsion, but now they are decidedly in vogue. Reptile images account for some of the most skillful and startlingly realistic contemporary carvings, and they have secured an impressive following among collectors.

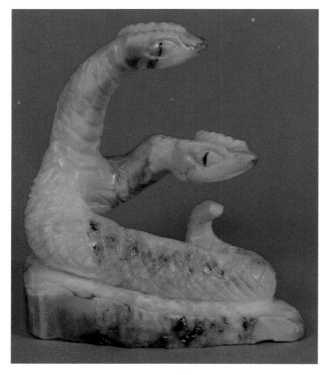

Two-headed snake, 3", carved of antler by Pernell Laate (Zuñi). Carved eyes. $180-225. (*Courtesy of Turning Point Gallery, Media, Pennsylvania.*)

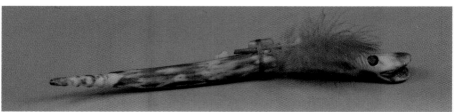

Rattlesnake, 6". Carved of antler with feather, shell, and coral bundle and turquoise eyes. Artist: Barry Yamutewa (Zuñi). $30-40. (*Courtesy of The Turquoise Shoppe, Lititz, Pennsylvania.*)

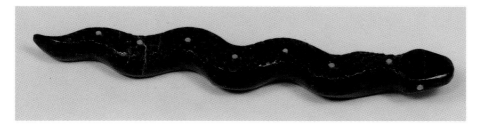

Green serpentine snake, 4". Turquoise inlay. Carved by Dan Poncho of Zuñi. $20-30. (*Courtesy of The Turquoise Shoppe, Lititz, Pennsylvania.*)

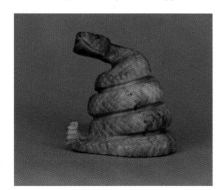

Coiled rattler, 1.5". Serpentine, carved by Christine Banteah of Zuñi. $65-80. (*Courtesy of Turning Point Gallery, Media, Pennsylvania.*)

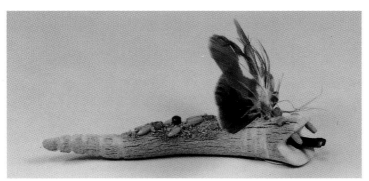

Fierce rattler, 3.25", carved of wood. Feathered headdress; decorated with crushed turquoise, shaped turquoise, coral, and lapis. Turquoise eyes and fangs with coral tongue. Artist unknown. $15-25. (*Courtesy of The Turquoise Shoppe, Lititz, Pennsylvania.*)

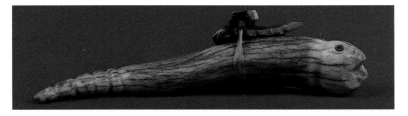

Navajo version of the rattlesnake. Made of antler. Drilled turquoise eyes with turquoise, coral, and pipestone nuggets on shell point bundle. $15-30. (*Courtesy of Palms Trading Company, Albuquerque, New Mexico.*)

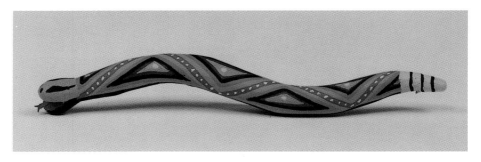

Painted, wooden snake, 4.5", by unknown artist. $65-75. (*Courtesy of The Turquoise Shoppe, Lititz, Pennsylvania.*)

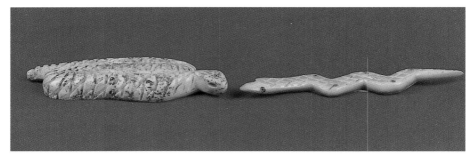

Two versions of the snake by Julia Norton (Navajo). Left: coiling, 2", serpentine. Right: slithering, 4", shell with drilled turquoise inlay. $20-35 each. (*Courtesy of Palms Trading Company, Albuquerque, New Mexico.*)

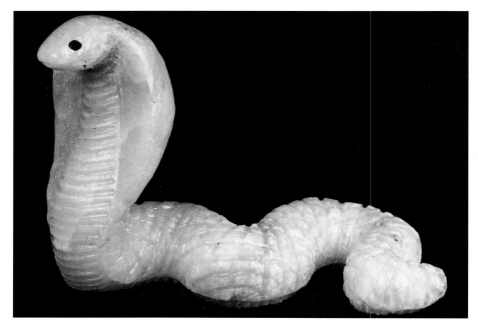

Cobra, 2.25". Alabaster with jet eye. Artist unknown. $30-50. (*Courtesy of the Turquoise Lady, Albuquerque, New Mexico.*)

120

Frog of green serpentine (1"). Artist: Lance Cheama of Zuñi. $60-75. (*Courtesy of Turning Point Gallery, Media, Pennsylvania.*)

Stone frog, 4", with turquoise inlay eyes and nostrils. Bundle of coral, turquoise, and heishe beads. Probably Weahkee family. $60-75. (*Courtesy of Kiva Indian Trading Post, Santa Fe, New Mexico.*)

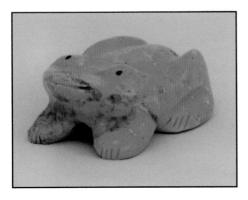

Turquoise frog, 2", by Zuñi artist Edward Bowannie. Jet inlay eyes. $65-75. (*Courtesy of private collection.*)

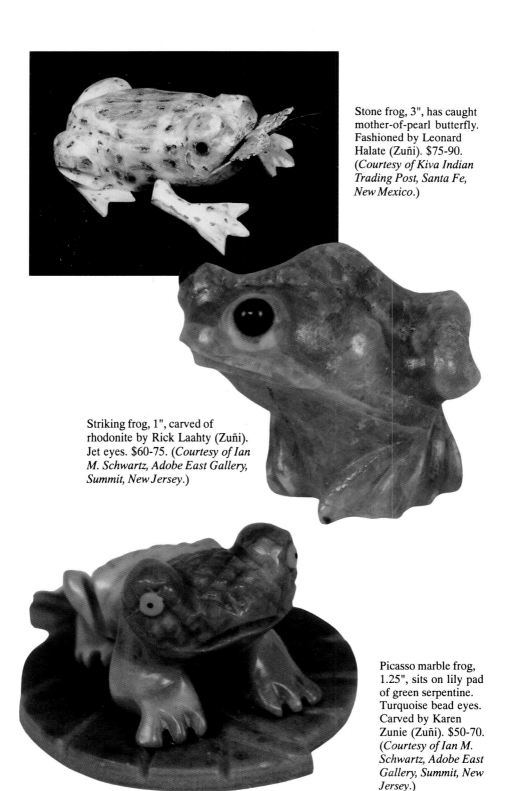

Stone frog, 3", has caught mother-of-pearl butterfly. Fashioned by Leonard Halate (Zuñi). $75-90. (*Courtesy of Kiva Indian Trading Post, Santa Fe, New Mexico.*)

Striking frog, 1", carved of rhodonite by Rick Laahty (Zuñi). Jet eyes. $60-75. (*Courtesy of Ian M. Schwartz, Adobe East Gallery, Summit, New Jersey.*)

Picasso marble frog, 1.25", sits on lily pad of green serpentine. Turquoise bead eyes. Carved by Karen Zunie (Zuñi). $50-70. (*Courtesy of Ian M. Schwartz, Adobe East Gallery, Summit, New Jersey.*)

Flat frog in traditional design, 3". Serpentine with turquoise inlay and drilled eyes. $25-40. (*Courtesy of Palms Trading Company, Albuquerque, New Mexico.*)

Tadpoles, each 3.5"; travertine (left) and serpentine (right). Drilled turquoise eyes. Artist unknown. $25-35. (*Courtesy of Kiva Indian Trading Post, Santa Fe, New Mexico.*)

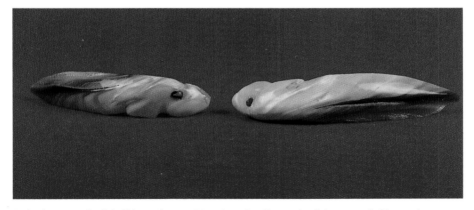

Tadpoles carved of shell by unknown Navajo artist. Turquoise inlay eyes (left); coral eyes (right). $20-30. (*Courtesy of Palms Trading Company, Albuquerque, New Mexico.*)

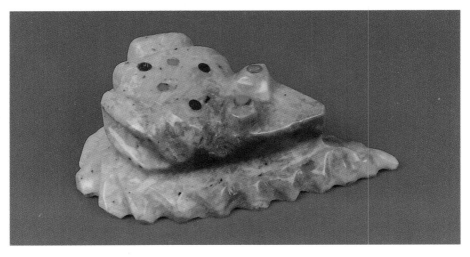

Serpentine frog, 3", decorated with turquoise and coral inlay. Rests on arrowhead carved of same stone. Artist unidentified. $25-35. (*Courtesy of Kiva Indian Trading Post, Santa Fe, New Mexico.*)

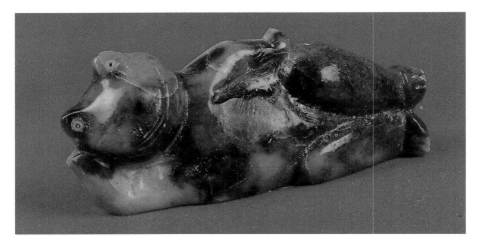

Personable frog in contemporary style, 1.25". Carved of serpentine by unknown Navajo artist. $25-35. (*Courtesy of Palms Trading Company, Albuquerque, New Mexico.*)

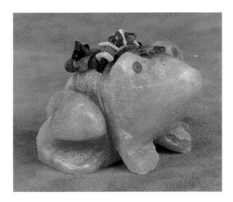

Contemporary style frog, 1.75". Carved of sunset alabaster by Louise Singer (Navajo). Drilled turquoise eyes with full bundle of arrow point, shell, turquoise, coral. $40-60. (*Courtesy of Palms Trading Company, Albuquerque, New Mexico.*)

124

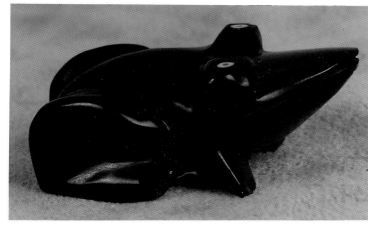

Julia Norton (Navajo) carved this frog of jet, 0.75". Features drilled turquoise eyes. $25-40. (*Courtesy of Palms Trading Company, Albuquerque, New Mexico.*)

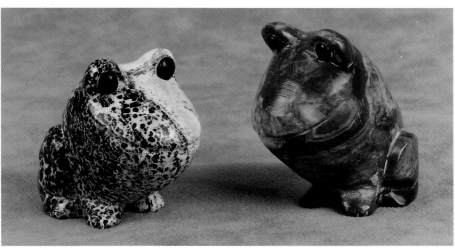

Two contemporary-style frogs, each 2.5". Eyes are jet. Left: argillite; right: serpentine. Fashioned by unidentified Navajo artist. $25-40. (*Courtesy of Palms Trading Company, Albuquerque, New Mexico.*)

Magnificent turtle, 4", made from spotted cowrie shell and silver work. Artist unknown. *Courtesy of Dolores Fitch-Basehore and the Estate of Katherine L. Fitch.* $500-600.

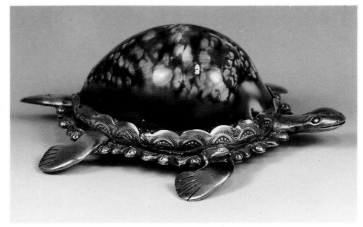

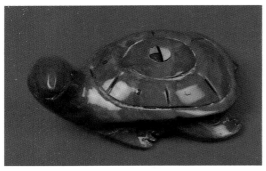

Green serpentine turtle, 2.25". Features delicate inlay of coral, turquoise, jet, and shell in sunface. Probably the work of Rhoda Quam. $90-120. (*Courtesy of Kiva Indian Trading Post, Santa Fe, New Mexico.*)

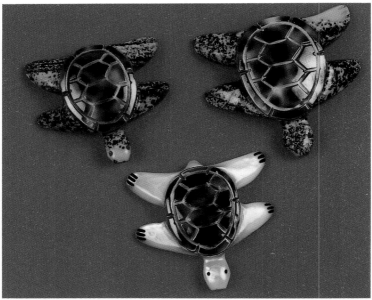

Three turtles (each approx. 1"). Top: gold lip mother-of-pearl and shell. Artist: Fabian Tsethlikai (Zuñi). $25-40. Bottom two: green serpentine bodies with shell backs; coral inlay eyes. Artist: Fabian Homer (Zuñi). $30-50. (*Courtesy of Andrews Pueblo Pottery and Art Gallery, Albuquerque, New Mexico.*)

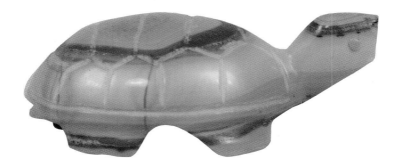

Dolomite turtle, 2", by Terrence Tsethlikai (Zuñi). $35-50. (*Courtesy of The Turquoise Shoppe, Lititz, Pennsylvania.*)

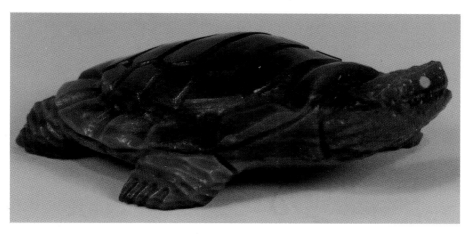

Realistic-style turtle of green serpentine, 2.5". Carved by Herbert Him (Zuñi). $120-135. (*Courtesy of Turning Point Gallery, Media, Pennsylvania.*)

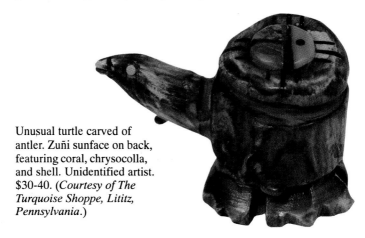

Unusual turtle carved of antler. Zuñi sunface on back, featuring coral, chrysocolla, and shell. Unidentified artist. $30-40. (*Courtesy of The Turquoise Shoppe, Lititz, Pennsylvania.*)

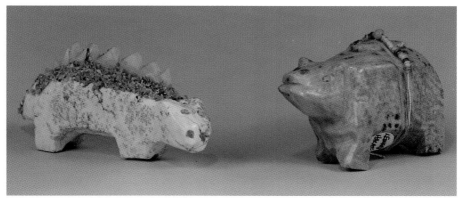

Left: Dinosaur/lizard, 4.5", serpentine with mother-of-pearl spikes along spine, sprinkled with crushed turquoise, $40-60. Right: bear, serpentine with bundle of turquoise and heishi, $35-55. Both have turquoise eyes and coral nostrils. Recognizable style, distinctive form and materials of Leonard Halate (Zuñi). (*Courtesy of Tumbleweed Trading, Manayunk, Pennsylvania.*)

127

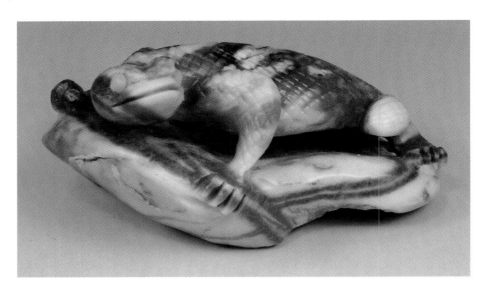

Terrific use of the coloring of picasso marble in this basking lizard, 3". By Lance Cheama (Zuñi). $300-350. (*Courtesy of private collection.*)

Green serpentine lizard, 4".
By Keith Bobelu of Zuñi.
Turquoise inlay eyes. $90-
110. (*Courtesy of Turning
Point Gallery, Media,
Pennsylvania.*)

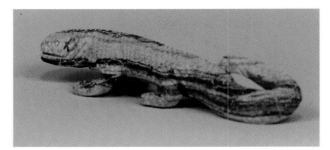

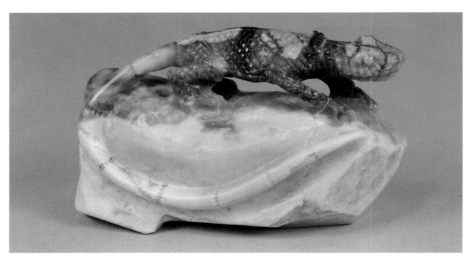

Chameleon on rock, 2.25". Picasso marble with turquoise eyes. By S. Natewa (Zuñi). $135-155. (*Courtesy of Turning Point Gallery, Media, Pennsylvania.*)

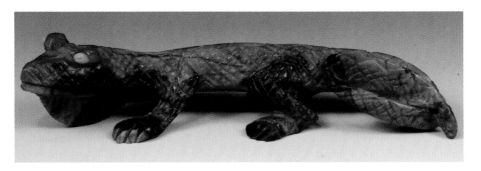

Picasso marble lizard, 3", with turquoise inlay eyes. By Lance Cheama. $300-350. (*Courtesy of private collection.*)

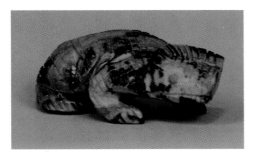

Horned Toad, 3". Picasso marble with turquoise eyes. By Nelson Yatsattie (Zuñi). $35-50. (*Courtesy of Turning Point Gallery, Media, Pennsylvania.*)

Horned Toads. Left: 3.25", by Melvin Sandoval (San Felipe), $90-110. Right: 2.5", jet, by Julia Norton (Navajo). $40-60. (*Courtesy of Tumbleweed Trading, Manayunk, Pennsylvania.*)

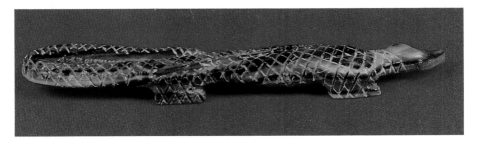

Alligator, 3". Serpentine with coral eyes. By Julia Norton (Navajo). $25-40. (*Courtesy of Palms Trading Company, Albuquerque, New Mexico.*)

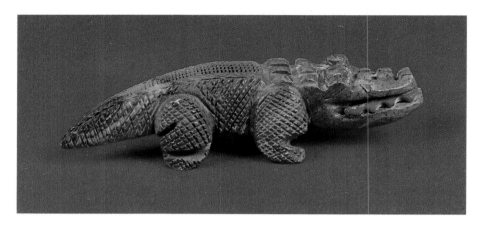

Alligator. Carved of serpentine by Louise Singer (Navajo). Turquoise dental work. $55-70. (*Courtesy of Palms Trading Company, Albuquerque, New Mexico.*)

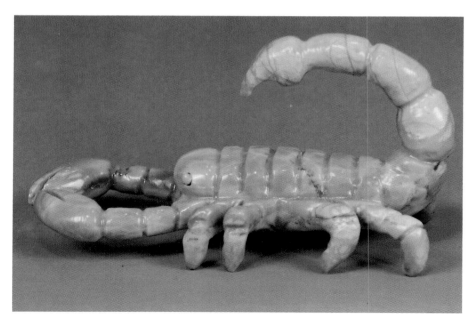

Scorpion, 2.5". Exquisitely carved of picasso marble by Vern Nieto. $75-100. (*Courtesy of Turning Point Gallery, Media, Pennsylvania.*)

MARINE BEINGS

Here are some creatures whom you'll find living in water. With the exception of fish, few are found in the Southwest. However, the carvers sometimes enjoy representing species not indigenous to their area. Market demand sometimes dictates the animals that are carved, and sometimes artists will accept commissions for special figures. Obviously, most of these creatures have no meaning within the religious system of the Southwestern Pueblos.

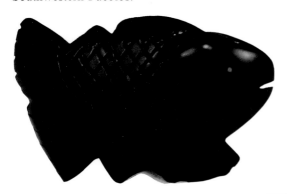

Jet fish, 3", by Gilbert Lonjose (Zuñi). $35-50. (*Courtesy of Tumbleweed Trading, Manayunk, Pennsylvania.*)

Serpentine fish, 1", by Keith Bobelu (Zuñi). $20-30. (*Courtesy of Andrews Pueblo Pottery and Art Gallery, Albuquerque, New Mexico.*)

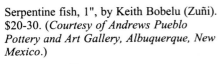

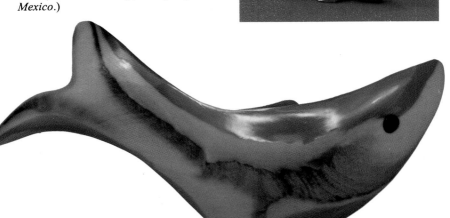

Cheryl Beyuka (Zuñi) fashioned this fish from green snail shell. $35-50. (*Courtesy of Ian M. Schwartz, Adobe East Gallery, Summit, New Jersey.*)

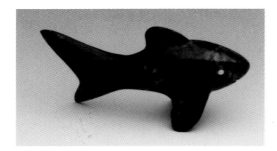

Shark, 1.5". Black marble with silver inlay eyes. Artist: Kenny Chavez of Zuñi. $25-40. (*Courtesy of Kevin Graepel.*)

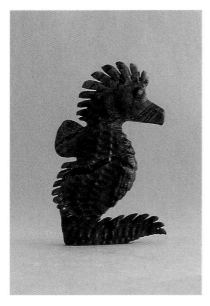

Seahorse, 3". Serpentine. Artist: Derrick Kaamasee (Zuñi). $100-150. (*Courtesy of Sunshine Studio, Santa Fe, New Mexico/ Photo by Challis Thiessen.*)

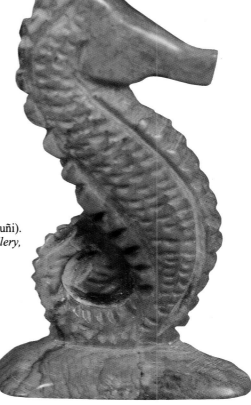

Seahorse, 1/5". Picasso marble with turquoise eyes. Artist: Celester Laate (Zuñi). $40-65. (*Courtesy of Turning Point Gallery, Media, Pennsylvania.*)

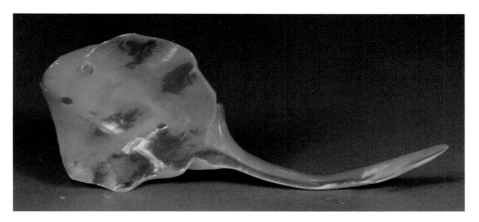

Sting Ray, 2". Mother-of-pearl with turquoise inlay eyes. Very delicate. Robert Halusewa, Zuñi carver. $30-50. (*Courtesy of Kiva Indian Trading Post, Santa Fe, New Mexico.*)

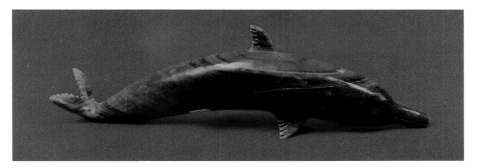

Dolphin, 5.25". Serpentine with pierced coral eye. Carver unknown. $50-70. (*Courtesy of Kiva Indian Trading Post, Santa Fe, New Mexico.*)

Dolphin, 1". Turquoise. Artist unknown. $40-55. (*Courtesy of Turquoise Lady, Albuquerque, New Mexico.*)

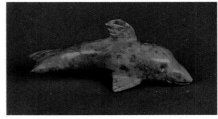

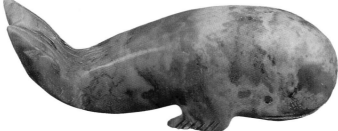

Whale, 2". Serpentine with turquoise eyes. Keith Bobelu of Zuñi, carver. $35-50. (*Courtesy of Palms Trading Company, Albuquerque, New Mexico.*)

133

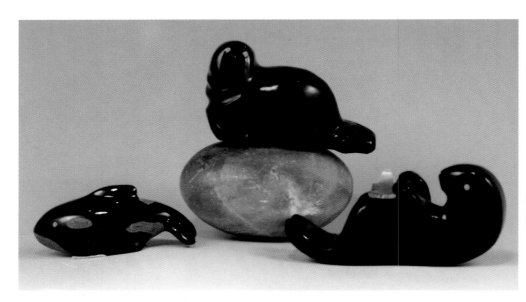

Left to right: Killer whale, 2", jet with turquoise eyes. Carved by Joel Nastacio (Zuñi), $30-50. Seal, 2.5", jet with turquoise eyes. Carved by Keith Bobelu (Zuñi), $40-60. Otter, 3", jet with turquoise eyes. Holds fish made of mother-of-pearl. Carved by Keith Bobelu. $50-70. (*Courtesy of Tumbleweed Trading, Manayunk, Pennsylvania.*)

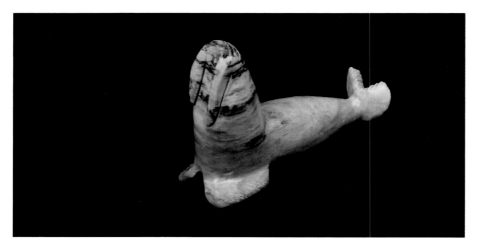

Walrus, 3". Green serpentine. Carver unknown. $50-65. (*Courtesy of Kiva Indian Trading Post, Santa Fe, New Mexico.*)

HUMAN BEINGS

Human figures also appear in fetish carvings and altar dolls. Priests or shamans, olla carriers, men and women, kachinas, and maidens, as well as rare carvings of human left feet and hands, may be crafted, although cultural or tribal taboos prohibit selling some of these sacred figures to outsiders. The maiden images apparently are not included in this ban. Some maiden figures are depicted carrying on their heads the *olla*, an earthenware jug with a rounded body and a flared, wide mouth at the top.

Other female figures wear the *tablita* (Spanish for "tablet"), a rectangular board headdress carved and painted usually with sky or cloud designs and decorated with feathers. The edges may be stair-shaped or terraced while at the center an open "T" shape symbolizes the wind. In the Tablita Dance (also called Corn Dance because it celebrates that crop), women wear these crowns, while the men wear white kilts and tasseled sandals symbolizing the rain. Still other maidens may be shaped like ears of corn or decorated with them. By far the most common human image reproduced is this corn maiden, not at all surprising given the secular and religious significance of corn among the Pueblo peoples.

In secular history the transmission of corn from Mexico around 1500 B.C. brought both an important staple food as well as the farming techniques with which to cultivate it. In religious practice corn carries sacred implications. The Hopi believe the first beings derived from corn. To the Zuñi, corn is both spirit and literal flesh of the six Corn Maidens. In *Pueblo Gods and Myths*, Hamilton A. Tyler distinguishes as many as ten such maidens, adding a seventh for sweet corn, an eighth for squash, and (rarely) a ninth and tenth for watermelon and musk melon, respectively. These sacred spirits yanked the first corn plants from the ground, pulling them to a height as high as they could reach. Joints formed at intervals along the stalks where their hands grasped and tugged. Without sacred corn, the People would starve. Eaten by humans, it becomes their flesh as well. This series of transformations invests corn with a spiritual power which makes it an essential element in all religious ceremonies and practices. Moreover, since only women participate in the care and storage of this staple, they gain both prestige and power from their stewardship.

Like the animals, birds, trees, etc., corn has color associations, as do the maidens who bring it. Ears of yellow, blue, red, and white mark the four directions, with multi and black designating the upper and lower regions. Corn shares an observable relationship to the stages of fire as well. Yellow when first lit, fire burns blue with smoke, bursting into full flame at red, fumeless flame at white. It shows the sparks of all colors (multi) and settles into a darkness which produces more heat than light, but from which it can reawaken as needed. In some maiden and youth rituals, the fire shifts into its various stages as participants embrace the stalks of different colors of corn (Tyler, *Pueblo Gods*, 11-12).

As a legend of generation, maturation, and fertility, the story of the Corn Maidens also accounts variously for seasonal changes, seasonal harvests, bird migration, even cycles of famine and impoverishment. Death and rebirth coincide with their presence and absence. In one version of the story, a Bow Priest offends one of the Corn Maidens. (Sometimes the "offense" takes the form of unwelcome sexual advances; sometimes it's presented as a legitimate, if overly ardent, marriage proposal.) On her account all

her maiden sisters leave for the ocean, taking the corn with them and inaugurating seven years of famine. A duck assists them in their flight, hiding the corn beneath her wings and secreting it beneath the water.

The stories inevitably conclude with the return of the maidens and the return of abundance. Along with seasonal and agricultural importance, these stories introduce issues of human reproduction, generation, and maturation. Implied is an understanding that youth desires to flee responsibility, but that all people must eventually take their places within the community. For the good of the Pueblo, even the sacred Maidens return to become spouses and mothers.

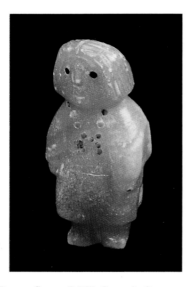

Human figure, 3.75". Carved of orange alabaster with jet eyes and turquoise inlay necklace. Artist: Sarah Leekya. $75-100. (*Courtesy of Kiva Indian Trading Post, Santa Fe, New Mexico.*)

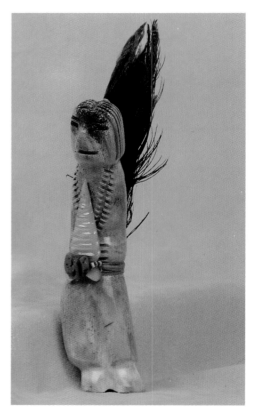

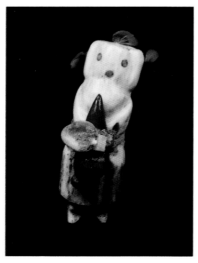

Altar priest with etched necklace. Carved of horn by Anderson Weahkee. Bound with offerings of shell, turquoise, coral, and feather. $65-90. (*Courtesy of Adobe Gallery, Albuquerque, New Mexico.*)

Altar doll carved of horn with red feathers in headdress and turquoise eyes. Pipestone point held at waist with shell bowl carrying offerings of ground turquoise, turquoise, and coral beads. Artist: Probably Marvelita Phillips (Zuñi). $30-45. (*Courtesy of Kiva Indian Trading Post, Santa Fe, New Mexico.*)

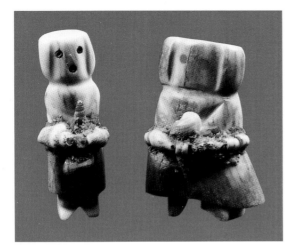

Altar dolls, 2.75". Carved of horn by Marvelita Phillips (Zuñi). Beads, shell points, and ground turquoise bundled at waist. $25-40 each. (*Courtesy of Andrews Pueblo Pottery and Art Gallery, Albuquerque, New Mexico.*)

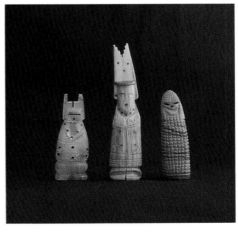

Left: Maiden wearing tablita headdress. Turquoise and coral inlay. Carved of gold-lip mother-of-pearl by Carl Etsate (Zuñi), $35-50. Center: Maiden with headdress, carved of antler by Delbert Cachini (Zuñi), $45-65. Right: Corn maiden, dolomite stone. Work of Quandelacy family (Zuñi), $50-65. (*Courtesy of Sunshine Studio, Santa Fe, New Mexico/Photo by Çhallis Thiessen.*)

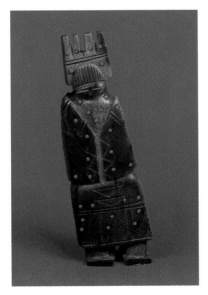

Maiden, 4", with tablita headdress. Antler. Etched details with turquoise inlay for eyes and adornment. Coral lips. Probably the work of Colvin Peina (Zuñi). $50-70. (*Courtesy of Fitch's Trading Post, Harrisburg, Pennsylvania.*)

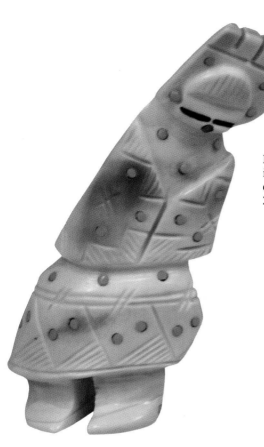

Maiden with tablita headdress, 3". Fossil ivory with turquoise inlay adornment and coral lips. Artist: Colvin Peina (Zuñi). $200-250. (*Courtesy of private collection.*)

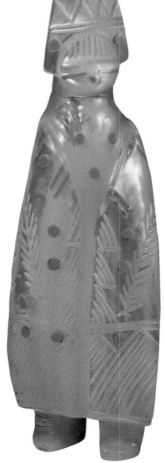

Maiden with tablita headdress, 4". Gold-lip mother-of-pearl with turquoise inlay adornment and etched details. Artist: Faye Quandelacy. $200-250. (*Courtesy of private collection.*)

138

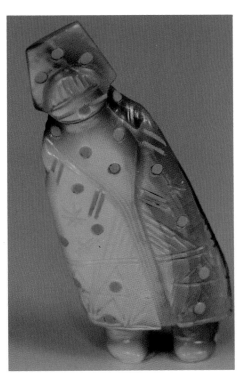

Maiden with tablita headdress (3"). Mother-of-pearl with turquoise inlay adornment and etched details. Carved by Colvin Peina of Zuñi. *Courtesy of Ian M. Schwartz, Adobe East Gallery, Summit, New Jersey.* $150-175.

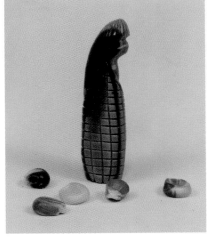

Green serpentine corn maiden, 2.25". Made by Quandelacy family. Turquoise inlay eyes and necklace. $45-60. (*Courtesy of The Turquoise Shoppe, Lititz, Pennsylvania.*)

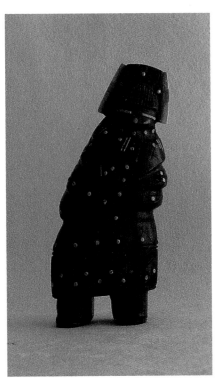

Maiden carved from ironwood, 5". Wears tablita headdress. Adorned with turquoise and coral inlay. By Colvin Peina of Zuñi. $200-250. (*Courtesy of Sunshine Studio, Santa Fe, New Mexico/Photo by Challis Thiessen.*)

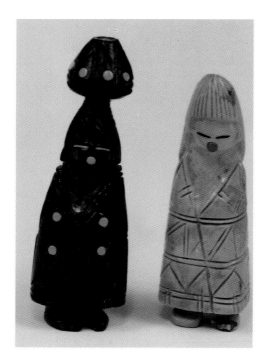

Two maidens by Colvin Peina. Left: maiden, 1.5", carries olla (water jar) on head. Ironwood with turquoise inlay. $100-120. Right: Turquoise maiden, 1.5". Coral lips and etched features. $90-110. (*Courtesy of The Turquoise Shoppe, Lititz, Pennsylvania.*)

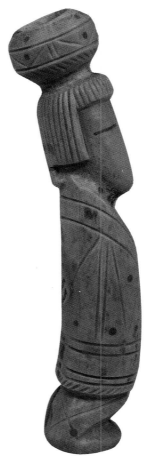

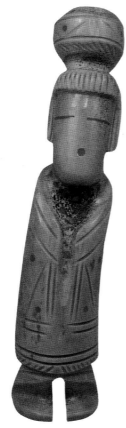

Side view of olla carrier. Olla or water vessel borne on head.

Olla Carrier, 4.25". Front view: Carved of antler and decorated with turquoise inlay. By Delbert Cachini (Zuñi). $135-155. (*Courtesy of The Turquoise Shoppe, Lititz, Pennsylvania.*)

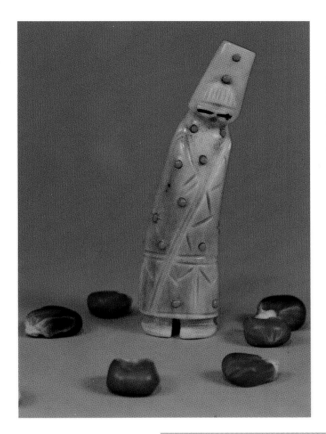

Maiden wearing tablita, 2.25". Carved of antler with turquoise inlay. Artist: Colvin Peina (Zuñi). $90-110. *(Courtesy of private collection.)*

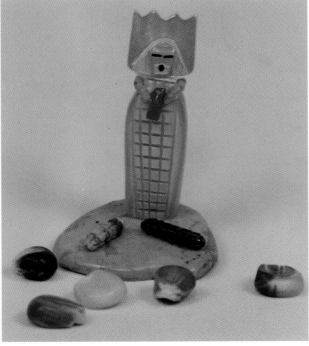

Corn maiden with tablita, 1.75". Carved of mother-of-pearl. Adorned with turquoise and coral necklace. Stands on turquoise base with jet and serpentine ears of corn. Artist unknown. $100-125. *(Courtesy of The Turquoise Shoppe, Lititz, Pennsylvania.)*

Chapter 12

FETISH NECKLACES

Unlike the pierced fetishes suspended on sinew that have occupied a place in Zuñi ritual and ceremony since ancient times, the popular so-called fetish necklaces we see today were clearly produced for the market in this century and carry no ritual significance. As adornment, however, they can be magnificent. The basic fetish necklace includes a mixture of these components: hand-carved stringing fetishes, heishi (pronounced HEE-SHEE), and findings or fastenings. A comparatively recent innovation, fetish necklaces began to attract popular interest in the 1930s and '40s largely because of the consummate skill of carvers Leekya Deyuse and Teddy Weahkee and the marketing efforts of trader C. G. Wallace. Leekya in particular is well known for mounting his fetish carvings in silver before attaching them.

In the 1950s, most fetish necklaces were strung with hand-cut, cylindrical Italian coral, difficult to cut and shape so that the necklace would hang evenly. This difficulty along with a shortage of coral led artists to try other methods of production. Some artists strung fetishes one upon the other; others separated the fetishes with heishi, pieces of shell, or other materials drilled and ground into beads.

Heishi, a specialty at Santo Domingo Pueblo, represents perhaps the oldest form of jewelry in the Southwest. In ancient times, heishi was made solely from shells traded to the Pueblo peoples from as far away as the Gulf of Mexico. Now that term refers to any of a variety of natural material hand-carved into tiny beads. Apparently the Zuñi, unhappy with the uneven texture and color of the shell, were slow to use heishi in their necklaces. However, as the quality improved, they adopted its use.[1]

In the earlier versions, the strands tended to be all the same length, but later tiering or "bibbing" (layering strands of different lengths) evolved to better display the workmanship. The variety available in these necklaces represents as great an array as the artists who produce their components. They may be all one color or a variety of colors; they may feature one animal or many, one strand or many strands. The carvings may represent the work of one artist, one family, or may combine the work of many artists.

In the past, the artists produced the components of the necklaces, which were then sold to traders or dealers. The traders assembled the pieces in patterns based on symmetry, color, or theme. The most common carving materials include serpentine, yellow lip mother-of-pearl, jet, abalone, coral, green snail, pipestone, melon shell, ivory, wood, and, of course, turquoise. Turquoise, however, must generally be stabilized in order to be drilled; in fact, in the process of shaping it into heishi, as much as sixty to seventy percent of turquoise may be lost to breakage.[2]

Generally, the necklace will include an odd number of carvings, paired items down each side with an extra piece, often a pendant, at the center. Since stone comprises much of the necklace, they can become quite heavy. Therefore many are still produced in the old style, the ends of the strands secured in wrappings of cotton twine which ride more comfortably and disperse weight upon the back of the neck better than modern silver hooks. Mark Bahti also suggests that better necklaces should be strung on strands of braided nylon, as the weight can snap single strands of wire or even silver chain. Care should be taken to keep the necklace dry and free of dirt and oil, which will age and weaken the string.

This tradition has continued to evolve through the skilled hands of such Zuñi artists as the Tsikewas, the Gaspers, Sarah Leekya, Lena Boone, Daisy Leonard, and the Delenas, to name just a few. Work by David Tsikewa (pronounced SY-KEE-WAH) provides wonderful examples of classic-style fetish necklaces. Authentic Tsikewa necklaces may bear a small silver tag that reads "DAVID."

Yet, as with all living arts, there remains room for innovation. Although purists may not recognize the work of Robert and Kristen Kaniatobe (he's Choctaw, she's not Native American) as fetish necklaces, they clearly bring exciting designs to this evolving tradition. To traditional materials they add brass inlay work, large contemporary-style fetishes, and beadwork of metal and glass.

Notes

[1]"Fetish Necklaces," *Indian Trader*, 21, no. 7 (July 1990): 9.
[2]"Introduction to Heishi," brochure (Albuquerque, New Mexico: Indian Arts & Crafts Association, 1988).

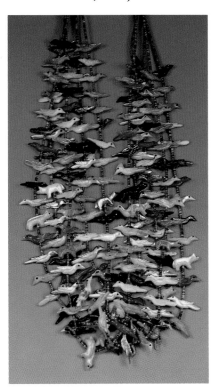

Magnificent 24", five-strand fetish necklace. Carved by David Tsikewa (Zuñi) in the 1950s. Uses all materials for carvings, although all eyes are jet. Mostly bird figures, some crested, some not. I've counted 11 bear fetishes among the flock. (How many can you find?) Animals are separated by brown heishe beads. Small, silver tag at the top (not pictured) reads "DAVID." Owner considers the necklace "Priceless." (*Courtesy of the Estate of Katherine L. Fitch.*)

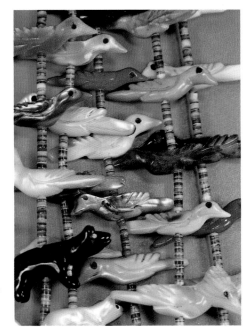

Detail of Tsikewa necklace. It was given to Katherine L. Fitch by the artist in friendship and with thanks for her work on behalf of Native American peoples.

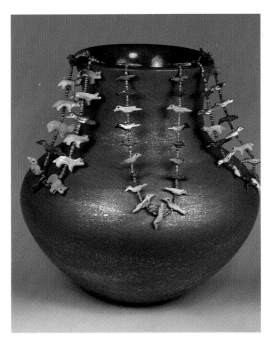

Three single-strand necklaces by David Tsikewa (Zuñi). Left: 20", mixed animals, mixed materials separated by heishi. Broken bird at bottom. $1,350-1,500. Center: 22", bird figures of mixed stones and heishi. $1,100-1,300. Right: 29", mixed animals, stones, and heishi. $1,350-1,500. All animals have jet inlay eyes. Necklaces have silver fastenings. (*Courtesy of the Estate of Katherine L. Fitch.*)

Detail of Tsikewa necklace on the left; broken turquoise bird at bottom. (*Courtesy of the Estate of Katherine L. Fitch.*)

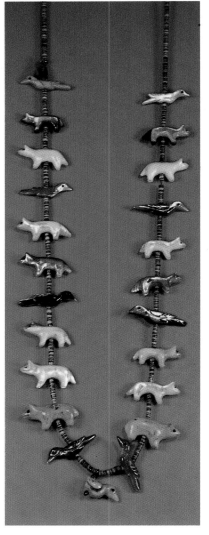

144

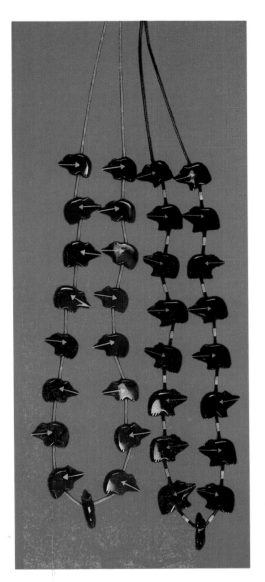

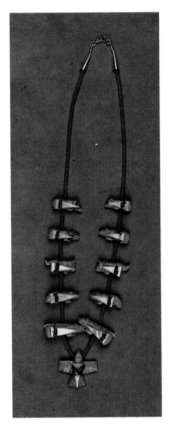

Example of same animal, same stone. Single-strand, 29" necklaces. Left: All brown bears (jasper) with turquoise inlay heartline, separated by turquoise heishi. $125-175. Right: All bears of jet. Turquoise inlay heartlines and heishi. Same carver, probably Zuñi, name unknown. $125-175. (*Courtesy of Southwestern Indian Art, Inc., Gallup, New Mexico.*)

Example of mixed figures, same stone. Turquoise animals all carry medicine bundles of turquoise, coral, jet, and shell point. Figures paired with those on opposite side of bird pendant. All have jet inlay eyes. Strung with coral heishi. $450-550. (*Courtesy of Palms Trading Company, Albuquerque, New Mexico.*)

145

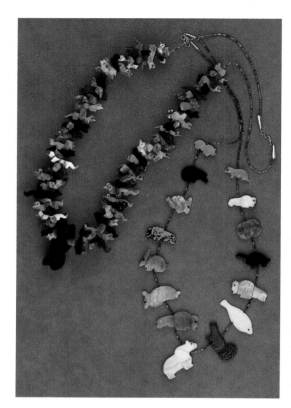

Example of multi-stone, single-strand necklaces, probably Zuñi workmanship. Left: mostly wolf fetishes strung without heishi to separate them. Large bear in pendant position. $400-500. Right: large, nicely carved animals of various stones, strung on brown and turquoise heishi in repeating pattern. Jet inlay eyes. $250-350. (*Courtesy of private collection.*)

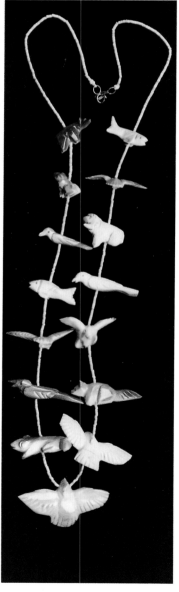

Example of one-color, all shell necklace with various animals separated by same-color heishi. Artist unknown. $100-150. (*Courtesy of Turquoise Lady, Albuquerque, New Mexico.*)

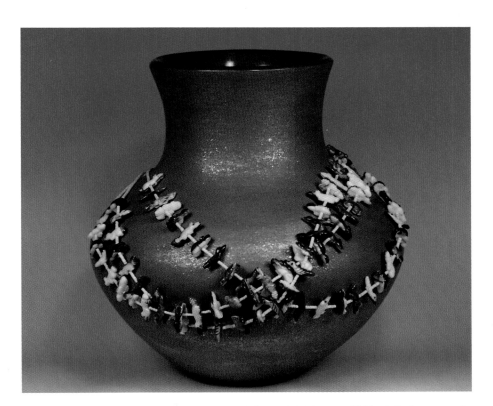

Example of mixed fetishes, same material, different heishi. From 1980s, 20", three-strand necklace of purple snail shell, strung with shell heishi. Carved by Angie Sanchez. $1,500-1,700. (*Courtesy of Fitch's Trading Post, Harrisburg, Pennsylvania.*)

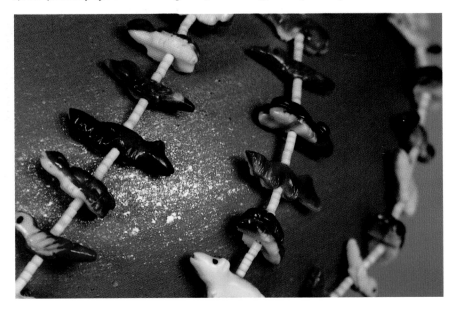

Detail from right side of purple snail shell necklace.

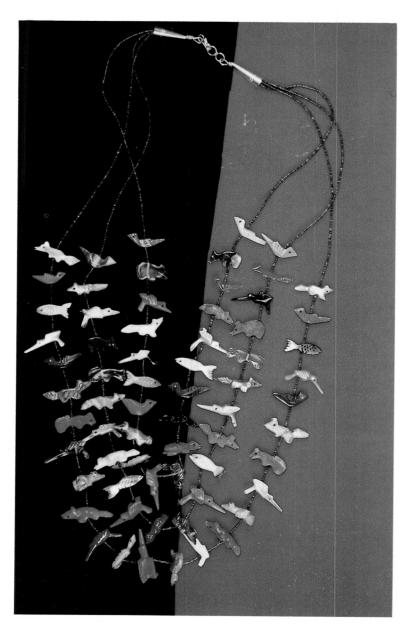

Example of multi-strand, multi-stone plus
amber, multi-animals necklace, strung with
brown heishi separation, 35". Carved by
Annette Hannaweeke of Zuñi. $2,000-2,500.
(*Courtesy of Southwestern Indian Art, Inc.,
Gallup, New Mexico.*)

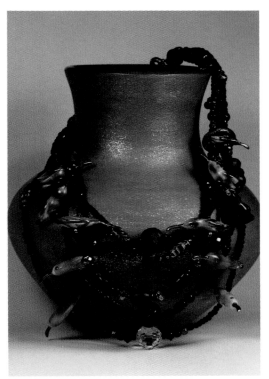

Example of evolving tradition of fetish necklaces. Hummingbirds. Five strands, 24", carved of Alaskan fossilized walrus ivory, brass, and stone. Glass beads replace heishi. "Rainbow Web" fetish neckwear by Robert and Kristen Kaniatobe (Choctaw/Anglo, respectively). $2,500-3,000. (*Courtesy of Dolores Fitch-Basehore.*)

Detail from upper right side. Bills and eyes of fossil-ivory hummingbirds are brass. Kaniatobe trademark is spider web etched somewhere on item. Brass hoop encircling strands symbolizes the circle of life.

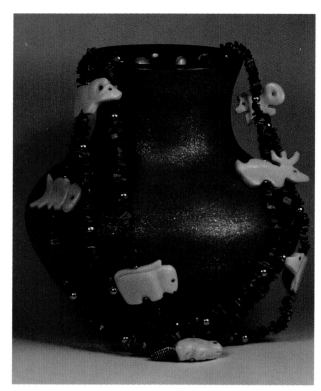

Color-coordinated, three-strand, 24" neckwear. Mixed fetish animals carved of "commercially raised" buffalo bone and strung with malachite and brass beads. By Robert and Kristen Kaniatobe. $2,500-3,000. (*Courtesy of Marjorie Levitan.*)

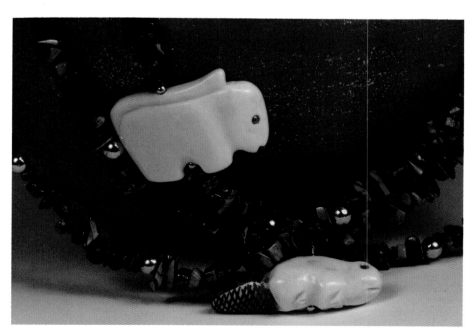

Detail from bottom center of Kaniatobe necklace. Mountain lion and beaver carvings with brass eyes.

ANNOTATED BIBLIOGRAPHY

Abeita, Andy and Roberta. "Sculptures in Stone." Brochure. n.d.

Bahti, Mark. *Southwestern Indian Arts & Crafts*. Revised Edition. Las Vegas: Nevada: KC Publications, Inc., 1983.

Bennett, Hal Zina. *Zuni Fetishes: Using Native American Objects for Meditation, Reflection, and Insight*. San Francisco: HarperSanFrancisco, 1993.

Bonvillain, Nancy. *The Zuni*. Indians of North America Series. New York: Chelsea House Publishers, 1995.

Branson, Oscar T. *Fetishes and Carvings of the Southwest*. Santa Fe, New Mexico: Treasure Chest Publications, Inc., 1976. Contains lots of information and great pictures of the varieties of Southwestern turquoise.

___*Turquoise: The Gem of the Centuries*. Santa Fe, New Mexico: Treasure Chest Publications, Inc., 1975.

Buffalo Horn Man, Gary and Sherry Firedancer. *Animal Energies*. Lexington, Kentucky: Dancing Otter Publishing, 1992.

Clark, La Verne Harrell. *They Sang for Horses: The Impact of the Horse on Navajo and Apache Folklore*. Phoenix, Arizona: University of Arizona Press, 1983.

Cushing, Frank Hamilton. *Zuni Fetishes*. Facsimile Edition. Reprinted with Introduction by Tom Bahti. Las Vegas, Nevada: KC Publications, 1988. First printed as Second Annual Report of the Bureau of Ethnology. Washington, D.C.: U. S. Government Printing Office, 1883.

Douthitt, Joe. "Introduction to Fetishes." Brochure. Albuquerque, New Mexico: Indian Arts and Crafts Association, 1988.

"Fetish Necklaces." *Indian Trader*. 21, No. 7 (July 1990): 9-10.

Finkelstein, Harold. *Zuni Fetish Carvings*. Decatur, Georgia: South West Connection, 1994.

Fitch-Basehore, Dolores. Interview. Fitch's Trading Post, Harrisburg, Pennsylvania. April 9, 1997.

Garbarino, Merwyn S. and Robert F. Sasso. *Native American Heritage*. Third Edition. Prospect Heights, Illinois: Waveland Press, Inc., 1994.

"Introduction to Heishi." Pamphlet. Albuquerque, New Mexico: Indian Arts and Crafts Association, 1988. Reprinted by permission of Wingspread Communications, publishers of *The Collector's Guides* to Albuquerque, Santa Fe, and Taos.

Karasik, Carol. *The Turquoise Trail: Native American Jewelry and Culture of the Southwest*. New York: Harry N. Abrams, Inc., 1993.

Kenagy, Susan G. "Made in the Zuni Style: Zuni Pueblo and the Arts of the Southwest." *Masterkey* 61, no. 4 (1985):11-20.

Kirk, Ruth F. *Zuni Fetishism*. Avanyu Publishing, Inc.: Albuquerque, New Mexico, 1988. Reprinted from *El Palace*, L, nos. 6, 7, 8, 9, and 10 (June-October 1943).

Klein, Barry T. *Reference Encyclopedia of the American Indian*. 6th Edition. West Nyack, New York: Todd Publications, 1993.

Ladd, Edmund J. "Zuni Economy." *Southwest*. Ed. Alfonzo Ortiz. Volume 9 of *Handbook of North American Indians*. Ed. William C. Sturtevant. Washington, D.C.: Smithsonian Institution, 1979.

McManis, Kent. *A Guide to Zuni Fetishes and Carvings*. Tucson, Arizona: Treasure Chest Books, 1995.

Medaugh, Connie. "Leonard Halate." *Tumbleweed Newsletter*. Winter 1997.

Parks, Stephen. "The Magic Breath of Prey." *Indian Trader* 21, no. 7 (July 1990): 5-8, 10-11.

Parsons, Elsie Clews. "Hopi and Zuni Ceremonialism." In *Memoirs of the American Anthropological Association*, no. 39. Menasha, Wisconsin: George Banta Publishing Company, 1933: 5-108.

Prucha, Francis Paul. *Atlas of American Indian Affairs*. Lincoln, Nebraska: University of Nebraska Press, 1990.

Reichard, Gladys A. *Navajo Religions: A Study of Symbolism*. New York: Pantheon, 1985.

Rodee, Marian and James Ostler. *The Fetish Carvers of Zuni*. Albuquerque, New Mexico: The Maxwell Museum of Anthropology and Zuni, New Mexico: The Pueblo of Zuni Arts and Crafts, 1990.

Schulthess, Emil. *Eternal Landscape: Utah, Arizona, Colorado, New Mexico*. Text by Sigmund Widmer. New York: Alfred A. Knopf, 1988.

Southwest Native American Arts and Material Culture: A Guide to Research. 2 Vol. Ed. Nancy J. Parezo, Ruth M. Perry, and Rebecca Allen. Studies in Ethnic Art series. Garland Reference Library of the Humanities. Vol. 1337. New York: Garland Publishing, Inc., 1991.

The Spirit World. American Indian Series. Alexandria, Virginia: TimeLife Books, Inc., 1992.

Strong, William Duncan. "An Analysis of Southwestern Society." *American Anthropologist* 29, no. 1 (1927): 1-61.

Tedlock, Barbara. *The Beautiful and the Dangerous: Encounters with the Zuni Indians*. New York: Viking Penguin, 1992.

Tedlock, Dennis. "Zuni Religion and World View." *Southwest*. Ed. Alfonso Ortiz. Volume 9 of *Handbook of North American Indians*. Ed. William C. Sturtevant. Washington, D.C.: Smithsonian Institution, 1979.

Tyler, Hamilton A. *Pueblo Animals and Myths*. The Civilization of the American Indian Series. Norman, Oklahoma: University of Oklahoma Press, 1975.

___ *Pueblo Birds and Myths*. The Civilization of the American Indian Series. Norman, Oklahoma: University of Oklahoma Press, 1979.

___*Pueblo Gods and Myths*. The Civilization of the American Indian Series. Norman, Oklahoma: University of Oklahoma Press, 1964.

Waldman, Carl. *Atlas of the North American Indians*. New York: Facts on File Publications, 1985.

Walker, Willard. "Zuni Semantic Categories." *Southwest*. Ed. Alfonso Ortiz. Volume 9 of *Handbook of North American Indians*. Ed. William C. Sturtevant. Washington, D.C.: Smithsonian Institution, 1979: 509-513.

Winokur, L. A. "Pushing Their Luck: Zuni Indians Peddle 'Magical' Charms." *Wall Street Journal*. Section A (April 28, 1993): 1, 6.

Wright, Barton. "Fact or Fallacy: The Meaning of Indian Design." Brochure. Albuquerque, New Mexico: Indian Arts and Crafts Association. Printed with permission of Southwestern Association on Indian Affairs, 1988. This book gives a thorough explanation of the politics of naming and an essential guide to identifying Native American initials and trademarks.

___*Hallmarks of the Southwest*. West Chester, Pennsylvania: Schiffer Publishing Ltd., 1989.

Zachary, Robert. "Introduction to Southwestern Indian Jewelry and Turquoise." Pamphlet. Albuquerque, New Mexico: Indian Arts and Crafts Association, 1988.

"Zuni Fetish Market Is 'Very Strong' Right Now." *Indian Trader* 21, no. 7 (July 1990): 5-6.

NATIVE AMERICAN FETISH CARVERS

Following is a list of Native American fetish carvers. It may be useful as you identify artists and document items in your collection. However, this list is not intended to be all-inclusive. With more than 400 fetish carvers working at the present time, it would be impossible to name them all. If artists' names don't appear, that doesn't mean their work is poor or inauthentic. By the same token, just because artists are listed does not ensure that you will like their work. Whenever tribal affiliations other than Zuñi are known, they are listed in parentheses following the artist's name. Generally, if no origin is given, assume Zuñi, or at least Zuñi style. Every effort has been made to record standardized spellings of the names; however, sometimes more than one accepted spelling exists. Any and all misspellings or mistaken affiliations are unintentional and regretable. For those errors and any other inaccuracies, I ask pardon.

Abeita, Andy (Isleta)
Abeita, Roberta (Ramah
 Navajo)
Acque, Garrick
Acque, Gary
Acque, Old Man
Ahiyite, Brian
Ahiyite, Tony
Allapowa, Bryce
Antez, Larry (Navajo)
Banteah, Christine
Banteah, Kent
Banteah, Sedrick
Banteah, Shawn
Banteah, Terry
Beyuke (Beyuka), Cheryl
Bica, Simon
Bobelu, Keith
Bobelu, Lorie
Bobelu, Vivella
Boone, Darrin
Boone, Emery
Boone, Evalena
Boone, Jimmy
Boone, Leland
Boone, Lena
Boone, Leonard
Boone, Rignie
Booqua, Marlo
Bowaneka, Harvey
Bowannie, Calvert
Bowekaty, Eugene
Bowekaty, Kenny
Burns, Gabriel

Burns, Gerald
Burns, Loren
Byers, Harriett(a)
M. C.
Cachini, Delbert
Cachini, Faylena(-lene)
Cachini, Wilford
Calavaza, Arnie
Calavaza, Barney
Calavaza, Claudia
Cellicion, Chris
Chattin, Daniel
Chavez, David
Chavez, Ephran
Chavez, Ida
Chavez, Kenny
Chavez, Lee
Chavez, Leroy
Chavez, Todd
Chavez, Vince
Cheama, Arvella
Cheama, Fabian
Cheama, Lance
Cheama, Louise
Cheama, Vivella
Cheama, Wilford
Cheechee, George
Cheeku, Albert
Cheeku, Michael
Chimoni, Harry
Chimoni, Stafford
Chinana, Charles (Jemez)
Chuyate, Lenny
Chuyate, Marilyn

Coble, Michael
Cooeyate, Edmund
Cooeyate, Lucy
Davis, Roy (Navajo)
Delena, Larry
Delena, Lita
Delena, Sam
Delena, Sammie
Deysee, Jr., Joseph
Deyuse, Leekya
Dutukewa, Howard
Epaloose, Brummett
Eriacho, Emery
Eriacho, Faye
Eriacho, Felino
Eriacho, Jeff
Etsate, Carl
Etsate, Todd
Eustace, Albert
Fragua, Samuel (Jemez)
Garnaat, Scott
Gasper, Braden
Gasper, Debra
Gasper, Diane
Gasper, Dinah
Gasper, Elroy
Gasper, Peter, Jr.
Gasper, Peter, Sr.
Ghahate, Randall
Gutierrez, Paul (Santa
 Clara)
Gutierrez, Dorothy (Santa
 Clara)
Halate, Herbert

Halate, Leonard
Halate, Reva
Halate, Vella
Haloo, Alvin
Haloo, Craig
Haloo, Miguel
Haloo, Ramie
Haloo, Raywee
Haloo, Wayne
Halusewa, Robert
Hannaweeke, Eddington
Hays, Tom (Plains)
Hesiloo, Camille
Him, Herbert
Him, Herbert, Jr.
Hines, Mark Swazo
 (Tesuque)
Homer, Alice
Homer, Bernard, Jr.
Homer, Bernard, Sr.
Homer, Fabian
Homer, Juana
Homer, Pat
Homer, Wilbert
Honawa, Milton
Hustito, Alonzo
Hustito, Clive
Hustito, Elfina
Hustito, Herbert
Hustito, Karen
Jones, Glen (Navajo)
Kaamasee, Colleen
Kaamasee, Derrick
Kaamasee, Elton
Kaamasee, Rose Nancy
Kaamasee, Rosita
Kalestewa, Jack
Kalestewa, Rickson
Kaniatobe, Kristen (Anglo)
Kaniatobe, Robert
 (Choctaw)
Kanteena, Raybert
Kaskalla, Lavina
Kaskalla, Lebert
Kaskalla, Leonard
Kaskalla, Libert
Kiyite, Fitz
Kucate, Arden
Kucate, Marnella
Kucate, Theodore
Kucate, Trilisha
Kushana, Verna
B. L.
D. L. (Jemez)
Laahty, Morris
Laahty, Ricky

Laate, Dawn
Laate, Celester
Laate, Max
Laate, Pernell
Laate, Willard
Lahaleon, Jerrold
Laiwakete, Donovan
Laiwakete, Fernando
Laiwakete, John
Laiwakete, Rodney
Laiwakete, Tony
Lamy, Alvert
Lamy, Averill
Lamy, Randall
Lang, Terry (Sioux-
 Cherokee)
Laselute, Bernie
Lasiloo, Al Runner
Lasiloo, Alan
Lasiloo, Amacita
Lasiloo, Lloyd
Lasiloo, Mike
Lasiloo, Priscilla
LeBouef, Jessie
Leekela, Mike
Leekela, Loren
Leekity, Joe
Leekity, Tricia
Leekya, Alice
Leekya, Delvin
Leekya, Francis
Leekya, Sarah
Leki, Edna
Lementino, Ed
Lementino, Tim
Leonard, Daisy
Leonard, Richard
Leonard, Terry
Lesarlley, Howard
Lewis, Alan
Livingston, Herbert
 (Ramah)
Lonasee, Florenda
Lonasee, Lorae
Lonjose, Danny
Lonjose, Gilbert
Lonsayatse, Yvonne
Lucio, Gale
Lucio, Jed
Lucio, Randy
Lunasee, Prudencia
Lunasee, Reynold
Lunasee, Ronnie
Lunasee, Rosella
Lunasee, Vernon
Mackel, Ernie "Woody"

Mackel, Tony
Mahkee, Jewelita
Mahkee, Ulysses
Mahooty, Eugene
Mahouti, Kyle
Malie, Lewis
Martinez, Carol
Martinez, Drucilla
Martinez, Florentino
Martza, Victor
Mecale, Anthony
Najera, Esteban
Nastacio, Farren
Nastacio, Joel
Nastacio, Joey
Nastacio, McKenzie
Nastacio, Pedia
Natachu, Pansy
Natachu, Peter
Natachu, Steven
Natewa, Daisy
Natewa, Jonathan
Natewa, LaVies
Natewa, Neil
Natewa, Staley
Nieto, Marjorie
Nieto, Travis
Nieto, Vern
Noche, Giovanna
Noche, Verna
Norton, Julia (Navajo)
Ohmsattie, Tony
Ohmsattie, Virginia
Owelicio, Franklin
Pablito, Elroy
Panteah, Clayton
Panteah, Kenny
Panteah, Roxanne
Peina, Claudia
Peina, Colvin
Peina, Ernest
Peynetsa, Hiram
Phillips, Brandon
Phillips, Marvelita
Pincion, Herbert
Pincion, Hubert
Pino, Albertson (Ramah
 Navajo)
Pino, Everett (Ramah
 Navajo)
Pino, Sarah Jane (Navajo)
Pinto, Cato
Poblano, Ida
Poblano, Leo
Poblano, Veronica
Poncho, Alex

154

Poncho, Dan
Poncho, Gordon
Poncho, Pierre
Poncho, Stephan
Poncho, Todd
Qualo, Octavius
Quam, Abby
Quam, Andres
Quam, Andrew
Quam, Andrew Emerson
Quam, Dan
Quam, Daniel, Jr.
Quam, Dwight
Quam, Eldred
Quam, Emerson Anderson
Quam, Gabriel
Quam, Georgette
Quam, Hubert
Quam, Jane
Quam, Joey
Quam, Johnny
Quam, Laura
Quam, Lynn
Quam, Melissa
Quam, Rhoda
Quam, Rick
Quam, Rosalia
Quam, Sylvia
Quam, Tyler
Quam, Virginia
Quandelacy, Andres
Quandelacy, Avery
Quandelacy, Barlow
Quandelacy, Dickie
Quandelacy, Ellen
Quandelacy, Faye
Quandelacy, Georgia(nne)
Quandelacy, Sandra
Quandelacy, Stewart

Quandelacy, Wilmer
Red Elk, Justin
Sanchez, Angie
Sanchez, Shokey
Sanchez, Dan (Isleta)
Sandoval, Melvin (San
 Felipe)
Shack, Russell
Shebola, Darren
Sheche, Aaron
Sheche, Arden
Sheche, Lorandina
Sheche, Thelma
Shetima, Jeff
Sice, Gabriel
Singer, Louise (Navajo)
Singer, Davin
Snow, Carmelia
Soseeah, Loubert
Soseeah, Monica
Suitza, Bobby
Terrazas, Augustine
Terrazas, Dion
Tom, Frank (Navajo)
Toombs, Virginia
Toya (Jemez)
Tsethlikai, Alex
Tsethlikai, Fabian
Tsethlikai, Raymond
Tsethlikai, Terrence
Tsethlikai, Vander
Tsikewa, Annette
Tsikewa, Bill
Tsikewa, David
Tsikewa, Jennie
Tsikewa, Lavina
Tsikewa, Mary
Tucson, Terrence
Ukestine (Unkestine), Leroy

Vacit, Rose
Walema, Preston
Wallace, Denise
Wallace, Louise
Wallace, Pat
Waseta, Emery
Wayne, Patricia
Weahkee, Anderson
Weahkee, Teddy
Weeka, Garrick
Weekoty, Fred
Wemytewa, Edward
Westika, Darrell
Westika, Myron
Westika, Todd
Williams, Teresa (Navajo)
Yamutewa, Barry
Yamutewa, Bernie
Yametuma, B.
Yaños, Zunie
Yatsattie (Yatsayte), Angel
Yatsattie, Brian
Yatsattie, Mike
Yatsattie, Nelson
Yawakia, Gordon
Yawakia, Jimmy
Yunie, Albenita Quandelacy
Yunie, Brian
Yunie, Jeffrey
Yuselew, Chris
Yuselew, Julius
Yuselew, Rydell
Yuselew, Sol
Zunie, Annette
Zunie, Bruce
Zunie, Karen
Zunie, Tracey
Zuni, Dorson

155

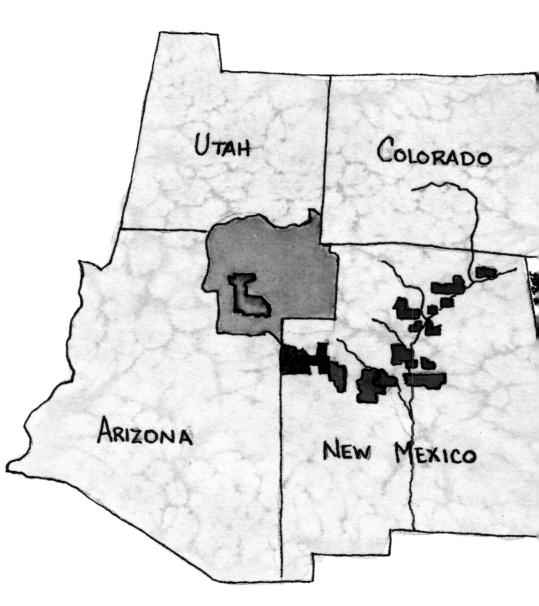

- Navajo
- Hopi
- Zuni
- Rio Grande Pueblos
- Ramah
- Acoma, Laguna & Isleta

GLOSSARY

Alabaster—Mostly light colored with a fine grain, it is a variety of gypsum rock which can be easily cut and carved.

Amber—A honey-yellow or brownish fossil resin, it is usually found in sedimentary rocks. Fairly soft, it loses clarity and luster if over-polished.

Argillite—A compact sedimentary rock, it is composed predominantly of clay.

Concretion—This rounded symmetrical stone is formed by the accumulation of minerals around a central core.

Cosmology—A philosophy or world view which tries to account for the origin of the universe.

Cowrie shell—A brightly polished, brilliantly colored tropical shell, it combines an oval shape with a rolled body and spire.

Dolomite—A fine to medium-grained rock, it is usually found in shades of cream, gray, or brown with streaks of yellow, brown, or red.

Fluorite—Found in a variety of transparent or translucent colors, its crystals usually form in limestone or igneous rock.

Fossil ivory—Often mined from middens or garbage pits, it is the remnants of tusks, teeth, etc. of long-dead animals.

Goldstone—Goldstone refers to any of several varieties of minerals (especially quartz or feldspar) spangled with bright particles of mica, hematite, or other sparkling materials. It can be synthetically produced by introducing these particles into glass.

Heishi—A specialty of Santo Domingo Pueblo, this term refers to handmade beads of shell, turquoise, or other materials. It is frequently added to jewelry or fetish medicine bundles.

Incised—A mark or pattern cut or engraved into another material, like stone or metal.

Inlay—The technique of setting stone or mosaic into silver, shell, or stone so that the surfaces of both are flush, evenly matched and smooth to the touch.

Jet—A tough, deep-black coal which can be polished to a bright, glassy luster. It is easily cut, sawed, carved, and polished.

Kachina—Supernatural spirits or gods of the Southwestern Pueblo tribes, they are impersonated at tribal ceremonials in specific, stylized human forms.

Kiva—A large chamber constructed in Southwestern Indian villages solely for ceremonial use by a designated clan. Wholly or partially underground, it is entered through the roof by means of a ladder. A village may have a number of kivas.

Lepidolite—A lavender-colored stone with a pearly sheen, lepidolite has a scaly texture formed by a combination of mica and lithium.

Matrix—Refers to the markings, lines, or blotches apparent when the original or mother rock shows through the surface of a stone.

Mesoamerica—The area extending from central Mexico to Honduras and Nicaragua in which diverse pre-Columbian civilizations flourished.

Micaceous clay—This is clay which contains bits and particles of shiny mica flakes.

Nadir—The lowest point or the direction down.

Nugget—A lump or chunk of stone or minerals.

Olla—A traditional water-carrier, the olla is an earthenware jug with a rounded body and a wide, flared mouth at the top.

Petroglyph—A kind of picture writing produced by drawing, painting, or carving symbols or pictures on skins, bark, or stone.

Picasso Marble—A particular color of marble characterized by a mixture of brown and black wavy bands.

Pipestone—A very fine-grained red clay, pipestone (also known as Catlinite) is soft when freshly quarried. It can be cut and shaped with a knife. It hardens as it dries.

Point—A generic term for any of a wide range of stone implements with tapering ends which may be fastened to arrows, spears, etc. When used on an arrow they may be called arrow-heads.

Prayer Sticks—About the length of a hand with fingers extended, these sacred sticks serve as religious offerings. Painted or carved, they may have pouches of corn or pollen attached to help secure the gods' favor and good will.

Pueblo—From the Spanish word for "village," this term can have several uses. It refers to the permanent multi-storied stone or adobe houses built by the agrarian Southwestern Indian tribes for defense. Not the name of a specific tribe, it can refer collectively to all the South-western tribes living in such structures, as in "Pueblo tribes." Further, the term can desig-nate the village itself, as in the incorporated Pueblo of Zuni.

Rhodochrosite—A pink to rose-red stone (manganese carbonate) with a pearly luster and white streaks.

Rhodonite—Brownish-red to pink, this stone (manganese silicate) usually displays significant black veining.

Septarian—This claystone concretion is crossed by networks of cracks in which minerals like calcium have solidified, leaving striking patterns of crystalline material.

Serpentine—Ranging in color from yellow to brown to green, serpentine is a stone commonly used for architectural and decorative purposes. Waxy in appearance, it is relatively easy to carve and takes a fine polish.

Stabilized turquoise—Turquoise stone which has been treated with resins or oils to make it harder and more workable. Stabilized turquoise is no longer considered gem quality.

Tablita—This rectangular board headdress, decorated with sky scenes and feathers, adorns women participating in ceremonial dances.

Travertine—Banded with color from yellow to red, travertine is a porous crystalline limestone formed in caves and hot springs. With its beautiful high gloss, it has many ornamental and architectural uses.

Zenith—This direction represents the highest point overhead.

Zuñi—This name refers both to the largest of the Pueblo tribes and to the village in which they live along the Zuñi River in western New Mexico.

INDEX